50 GEMS

Oxfordshire

DAVID MEARA

AMBERLEY

To Rosemary, with love and gratitude

First published 2022

Amberley Publishing
The Hill, Stroud
Gloucestershire, GL5 4EP

www.amberley-books.com

Copyright © David Meara, 2022

Map contains Ordnance Survey data © Crown copyright and database right [2022]

The right of David Meara to be identified as the Author
of this work has been asserted in accordance with the
Copyrights, Designs and Patents Act 1988.

British Library Cataloguing in Publication Data.
A catalogue record for this book is available from the British Library.

ISBN 978 1 3981 0952 0 (paperback)
ISBN 978 1 3981 0953 7 (ebook)

Typesetting by SJmagic DESIGN SERVICES, India.
Printed in Great Britain.

Contents

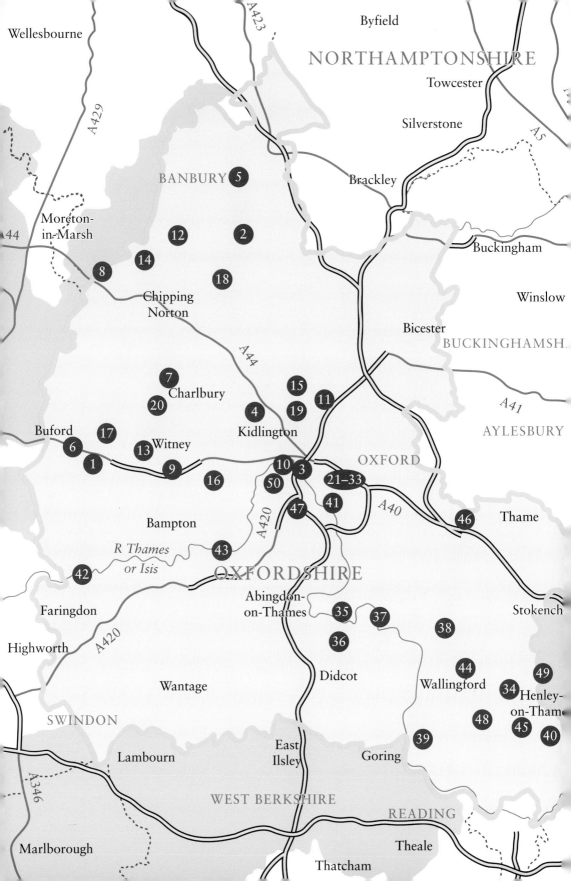

Introduction

Mention of Oxfordshire conjures up images of dreaming spires, gilded youth, *Brideshead Revisited*, Henley Rowing Regatta, the wild antics of the Mitford sisters in the interwar years, and the splendours of Blenheim Palace. But although these are all good reasons to visit the county, there is much more to Oxfordshire than nostalgia and the lives of the aristocracy.

Oxfordshire is a county of contrasts, lying between the Midlands to the north, the River Thames to the south, the Chiltern Hills to the east and the Cotswolds to the west. In the northern part of the county the landscape is formed by the lias limestone which creates dramatic shapes in the hills and ridges, while villages like Adderbury, Hornton, the Barfords and the Tews glow with the golden-brown ironstone from which the cottages and houses are built. In the middle of the county the stone colour changes to the golden-grey of the Cotswolds, and further south we arrive in the chalk of the Chilterns.

The landscape is full of history, with the remains of the dense woodland of the old royal Forest of Wychwood, and delightful towns such as Burford in the valley of the River Windrush, Henley, sitting sedately beside the River Thames, and Woodstock, famous for Blenheim Palace, the ancestral home of the Dukes of Marlborough and the grandest house in the county.

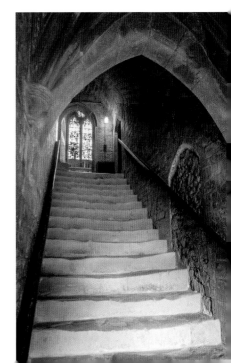

The vaulted staircase leading to the chapel, Broughton Castle. (Stuart Vallis)

The county is rich in medieval churches, with lovely Norman carving at Great Rollright and Brize Norton, soaring spires at Bampton and Bloxham, and impressive collections of monuments at Broughton, Somerton and Stanton Harcourt. There are also fine medieval tithe barns at Swalcliffe, Upper Heyford and Adderbury, all on estates owned by New College, Oxford.

John Piper, in his Shell Guide to Oxfordshire, described the map of the county as looking like a flying cloud, and right in the middle of the cloud sits the city of dreaming spires, Oxford itself, the jewel in the county's crown, shaped like a four-pointed star, and lying at the bottom of a shallow bowl of surrounding hills. A centre of learning was established here in the twelfth century when scholars gathered in 'halls of residence' under a master, which evolved into the colleges that make up the university today. Amongst the beauty of these honey-coloured ancient buildings I shall highlight some well-known gems, but also lesser-known sites of interest, the views of Oxford from the surrounding hills, punting on the leafy Cherwell, the Covered Market, the wonderfully exotic collections in the University and Pitt Rivers Museums, a medieval brass at Rotherfield Greys, the Brewery at Hook Norton, the glories of Wytham Woods, and the Rose Revived Inn at Newbridge by the Thames.

I have divided the book into three sections, covering the parts of the county to the north and to the south of Oxford, and the City of Oxford itself. I have tried to make each 'gem' the focus for a number of other interesting sights and places to visit, so that discovering one gem may lead the visitor on to discover other treasures nearby. In this way I hope the book presents an enticing picture of the rich variety of experiences and places which the county of Oxfordshire offers.

Opposite: A Morris Eight family saloon car standing in front of Nuffield Place, home of William Morris, Lord Nuffield. (Stuart Vallis)

Below: King Class locomotive No. 6023 *King Edward II* at Didcot Railway Centre. (Stuart Vallis)

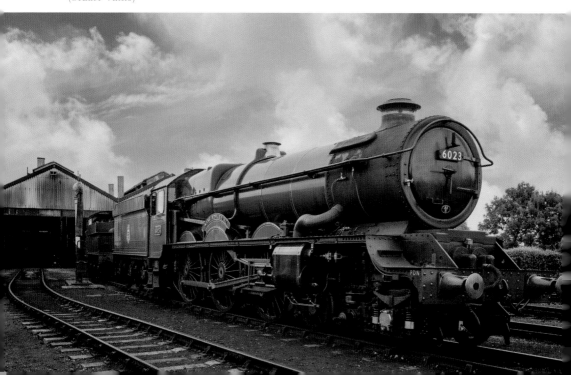

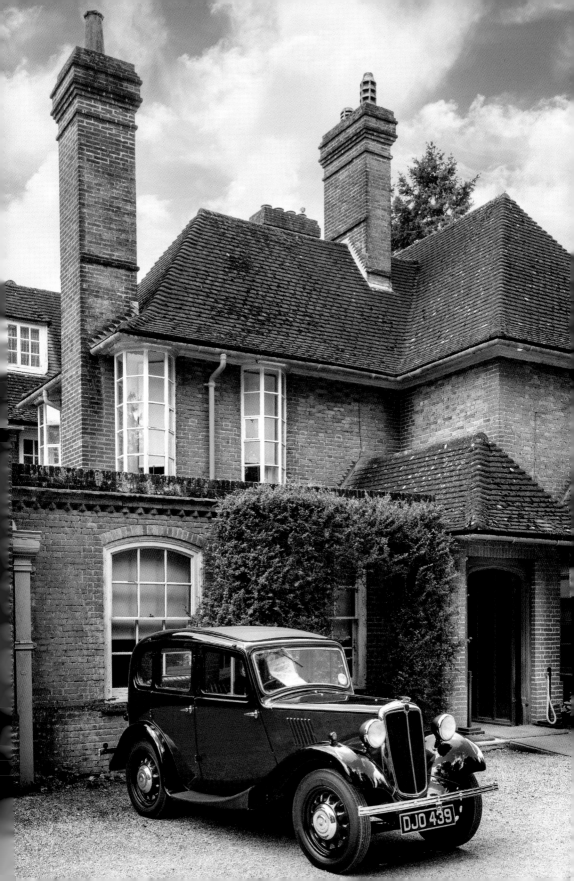

North Oxfordshire

1. Asthall

I have chosen to begin with this village because it is a lovely place in a beautiful but little-visited part of the Windrush Valley between Burford and Minster Lovell. For its small size it is rich in history. There was a settlement here in Roman times, on Akeman Street, which linked Cirencester with St Albans. Above the village on the hill is Asthall Barrow, a Saxon burial place, and the village church of St Nicholas dates back to the twelfth century. It contains the fine fourteenth-century effigy of Lady Joan Cornwall, and there is some fourteenth-century glass in the Cornwall Chapel.

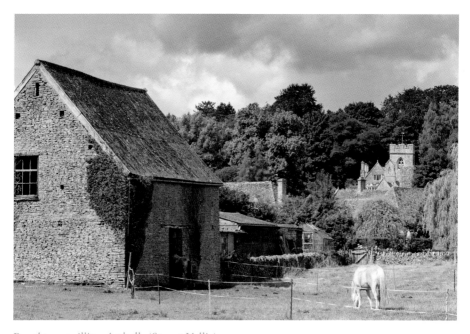

Rural tranquillity, Asthall. (Stuart Vallis)

In the summer of 2009 a hoard of 110 gold coins was discovered during building work at Asthall. The coins date from 1470 to 1526 and are believed to have been buried during the reign of Henry VIII. They were bought by the Ashmolean Museum in Oxford and are on display there.

The large Jacobean manor house, Asthall Manor, was built around 1620 and looks across the churchyard and down the village street towards the old river bridge. In 1913 the house was enlarged for the 2nd Baron Redesdale, the father of the famous Mitford sisters, who lived here until 1926 when they moved to Swinbrook. It was here that Nancy Mitford wrote most of *Love in a Cold Climate*, which was published in 1949. Nancy, along with her sisters Jessica, Diana, Unity and Pamela, was regarded as one of the 'Bright Young Things' in the years between the two world wars.

Asthall is full of lovely buildings in a beautiful setting. If you want some refreshment the Maytime Inn is a delightful seventeenth-century inn, now a gastropub, with a boules pitch, gin bar and fine views over the Oxfordshire countryside. The view from the bridge of the village and the willow-lined River Windrush is 'Quintessential England'. What better introduction to Oxfordshire could there be?

2. Barford St Michael and St John

Standing on either side of the River Swere, these two ironstone villages in the open country in the north of the county are delightful places to visit, especially when the sun illuminates the dark honey-coloured houses and cottages. In St Michael the lanes run down the hill to the river, the cottages and the George Inn dating from 1679. The church of St Michael sits on the hill with its squat Norman tower and doorways with zigzag decoration dating from around AD 1150. The North Door has twelfth-century ornamental ironwork, and inside you will find a fifteenth-century screen and bench ends. There is a memorial brass to William and Joan Foxe, 1495, showing the husband in civilian dress with a pouch at his waist, and his wife Joan in a stylish 'butterfly' headdress.

Barford St John is a smaller village, with church, manor house and a few cottages. The church is tucked away behind the manor house, and although it dates from about 1150 AD, it was substantially rebuilt in 1860–61 by the architect George Edmund Street, who also rebuilt Manor Farm. The church boasts a Norman font, and a perky octagonal tower.

Although there has been substantial development in the twentieth century it is mostly sympathetic, and these villages clustering together beside the River Swere form an attractive and picturesque ensemble, and a good introduction to the northern part of Oxfordshire.

Above: A row of ironstone cottages, Barford St Michael. (Stuart Vallis)

Left: Octagonal church tower, 1860, by George Edward Street, Barford St John. (Stuart Vallis)

3. Binsey

Binsey is a rural oasis by the River Thames, with fine views across Port Meadow and only around a mile and a half from the centre of Oxford. It boasts a number of delights, including the Perch Inn, a delightful seventeenth-century thatched building that is one of Oxford's oldest pubs, and in recent years a favourite haunt of Inspector Morse. Beyond the pub a narrow lane leads through an avenue of chestnut trees to the tiny church of St Margaret, with its twelfth-century doorway with zigzag mouldings and font of the same period. The church is famous for the Treacle Well in the churchyard, which is described by the dormouse at the Mad Hatter's tea party in Lewis Carroll's *Alice's Adventures in Wonderland*. The name derives from the medieval word 'triacle', which meant any liquid with healing properties.

The well is associated with the story of St Frideswide, Oxford's patron saint. She was the only daughter of an Anglo-Saxon king, who chose a life of religious devotion instead of royal power. She was courted by a pagan king, Algar of Mercia, who asked for her hand in marriage. When she refused him he threatened to abduct her, and so she fled to Oxford where she hid in the woods at Binsey. She established a chapel there, and a holy well, but King Algar came to Oxford, once again prepared to take her by force. As he approached the town he was struck blind by a bolt of lightning, but Frideswide took pity on him, prayed to St Margaret of Antioch, and used water from the well to restore his sight. Algar returned to his kingdom, and Frideswide founded an oratory on the site of the present twelfth-century church, and a nunnery in Oxford, where Christ Church College and Cathedral stand today.

Right: Interior of St Margaret's Church, Binsey, with twelfth-century font and thirteenth-century chancel arch. (Stuart Vallis)

Below: St Margaret's Well, Binsey. (Stuart Vallis)

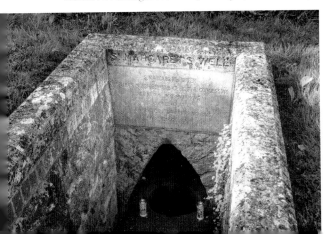

4. Blenheim Palace and Bladon

Situated on the edge of the market town of Woodstock, Blenheim Palace is the ancestral home of the Dukes of Marlborough. It is named after the Battle of Blenheim (1704), and was the reward of a grateful nation for John Churchill, 1st Duke of Marlborough, who successfully fought against the French and Bavarian armies.

You approach the palace through a massive gateway adorned with a gilded trophy. Set in a 2,500-acre park, the buildings in the English Baroque style, and built from golden Taynton stone, cover 7 acres, a vast edifice with north and south fronts stretching around 350 feet in length. It was designed by Sir John Vanbrugh, and the building work was superintended by the Duchess of Marlborough, who had the great tapestries made that hang in the main rooms. The library, 180 feet in length, was the biggest of any private building in the world. At one point in the house you can see the light through a line of ten keyholes in the fine doors.

Unfortunately, the Duchess quarrelled with everyone involved in the building work, and the government became increasingly disenchanted with the project, only reluctantly paying the bills, with the result that the project took twenty years to complete. She had really wanted Sir Christopher Wren to design what she wanted, and she constantly criticised Sir John Vanbrugh for his extravagant and grandiose design. Following a particularly bitter argument the Duchess banned Vanbrugh from the site. The completed building divided opinion, and still does, but no one can fail to be impressed by the severe grandeur of the vast building surrounded by its beautiful parkland.

Blenheim Palace was the birthplace of the 1st Duke's famous descendant, Sir Winston Churchill, Prime Minister during the Second World War, when he made

North Front, Blenheim Palace. (Stuart Vallis)

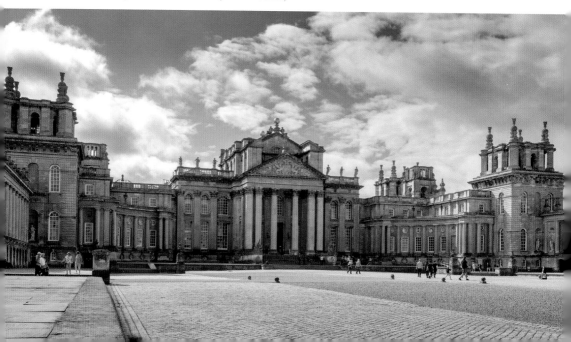

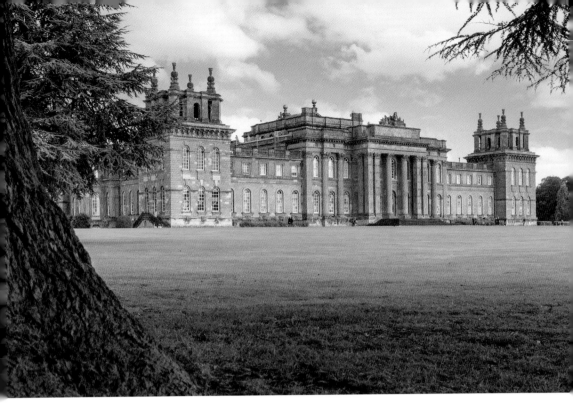

Above: South Front, Blenheim Palace. (Stuart Vallis)

Right: Grave of Sir Winston Churchill, 1874–1965, St Martin's Church, Bladon. (Stuart Vallis)

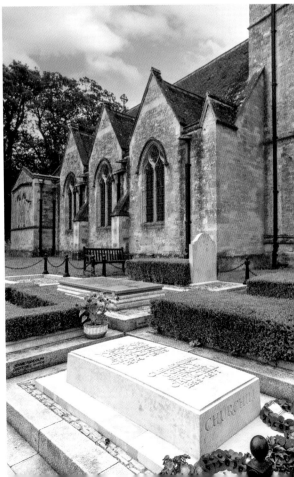

his reputation as Britain's pugnacious wartime leader, with his inspired speeches to the nation and his familiar 'V' for victory salute. After a somewhat chequered previous military and political career, he became Prime Minister in 1940, helped to shape the Atlantic Charter that engaged the support of America, masterminded the Battle of Britain strategy and oversaw the North Africa Campaign. On his death in 1965 he was given a state funeral, and his body was buried in the churchyard at Bladon, a small village within sight of the palace. His grave remains a place of pilgrimage to this day, and there is an exhibition of his life in the suite of rooms in Blenheim Palace in which he was born.

5. Broughton Castle

Appearing through the trees of its surrounding parkland, Broughton Castle is a stunning example of an English fortified manor house, complete with its own moat and glorious gardens. Unsurprisingly it has been the location for a number of well-known films, including *The Madness of King George* (1994), *Shakespeare in Love* (1998), and *Jane Eyre* (2011).

The gatehouse, with spire of St Mary's Church, Broughton Castle. (Stuart Vallis)

It was originally built by John de Broughton in the fourteenth century, on a site where three streams came together. It was sold in 1377 to William of Wykeham, Bishop of Winchester, and came into the possession of the Fiennes family in 1450. It has remained in the family ever since, who rejoice in their full name of Twisleton-Wykeham-Fiennes, Barons Saye and Sele.

In 1554 the present Tudor house was built, which saw visits by the Parliamentarians during the Civil War, when the 1st Viscount, a staunch Parliamentarian, plotted the Great Rebellion against King Charles I with the Puritan leaders Pym, Hampden and Essex. By the late nineteenth century it had fallen into decay. It was rescued and restored to its present glory in the Edwardian period.

The fine gatehouse and the chapel date from the fourteenth century, and there is a great hall, long gallery, and on the first floor fine and elaborate chimney pieces and plasterwork ceilings.

The gardens have impressive herbaceous borders which are at their best in summer, and just beyond the moat is the thirteenth-century church with a handsome tower and broach spire. Inside there is a lovely stone screen and many tombs of the former owners of the castle, and of the Fiennes family.

Interior of St Mary's Broughton, showing tombs and monuments of the Wykeham and Fiennes families. (Stuart Vallis)

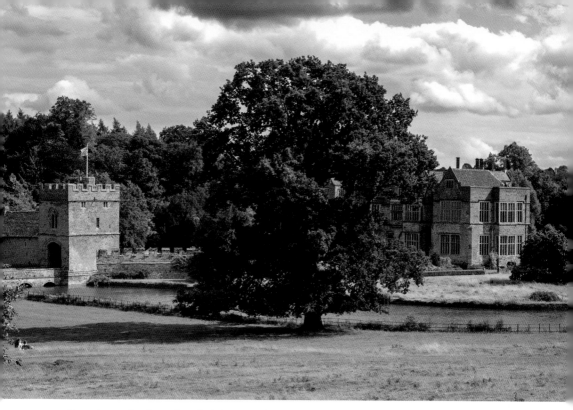

Broughton Castle, a fortified fourteenth-century manor house, showing the gatehouse, spectacular moat, and sixteenth-century front of the main building. (Stuart Vallis)

The youngest son of the 21st Baron Saye and Sele, William Fiennes, published a memoir in 2009 about growing up at the castle, *The Music Room*, which, while never mentioning the castle by name, gives a delightful account of life within this historic dwelling that was his home.

6. Burford

Turn off the busy A40 around 20 miles west of Oxford and approach Burford from the south as the ancient High Street slopes gracefully down from the Wolds to the River Windrush below. It is a fine sight to see the dignified old houses tumbling down the side of the hill, all different shapes and sizes, with side streets disappearing enticingly to right and left.

Fortunately for Burford the Great Western Railway took the route up the Evenlode Valley, not that of the Windrush, so it has retained its compact size and character. There was originally a fortified ford in Anglo-Saxon times, and gradually the town grew to become an important crossroads and a thriving centre of the wool trade in medieval times. The fine church of St John the Baptist reflects this later prosperity. Begun in the twelfth century with a Norman tower and a spire soaring to 180 feet

of *c.* 1400, as the town prospered the people added further aisles and chapels. It is full of good monuments, including those to Sir Lawrence Tanfield; Christopher Kempster, Clerk of the Works to Sir Christopher Wren at St Paul's Cathedral; tombs to the Sylvester family; and a fine memorial brass to John and Alys Spicer, 1437. During the English Civil War the church was used to imprison a group of Levellers who had mutinied against Oliver Cromwell. Three of the leaders were shot by the Parliamentarians, and you can still see the bullet holes on the outside wall of the church. One prisoner left a permanent record by scratching his name on the font, 'Anthony Sedley, 1649 Prisner'.

Clustered around the church are the Almshouses on Church Green and the sixteenth-century Grammar School, while on every side you can see ancient gables and doorways and mullioned windows. The River Windrush curls around the churchyard, spanned by an old medieval stone bridge. At the top of the hill the main street is lined with trees, beyond which are honey-coloured stone cottages, while further down there are inns, tea shops, antique shops and other emporia. On Witney Street there is The Great House of 1690, and on Sheep Street there are two excellent hotels, The Lamb Inn and The Bay Tree Hotel. The Tolsey is an early Tudor building on stone pillars which houses a small museum, with an exhibition of the trades that made the town prosperous, from brewing to leather-working to clarinet-making and bell-founding. Tucked away off the High Street is Burford Priory, which stands on the site of a thirteenth-century Augustinian priory. It is now a private house.

Although the town was at its most important between the fourteenth and sixteenth centuries, it is now celebrated as a delightful survival of a traditional market town, and the gateway to the Cotswolds. Try to visit it early on a Sunday morning when there is little traffic.

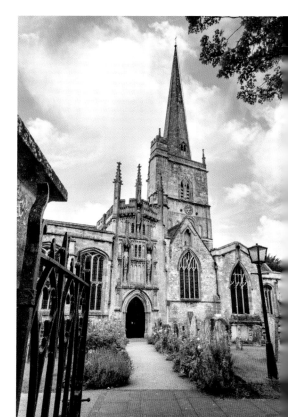

The fine fifteenth-century porch and spire of the Church of St John the Baptist, Burford. (Stuart Vallis)

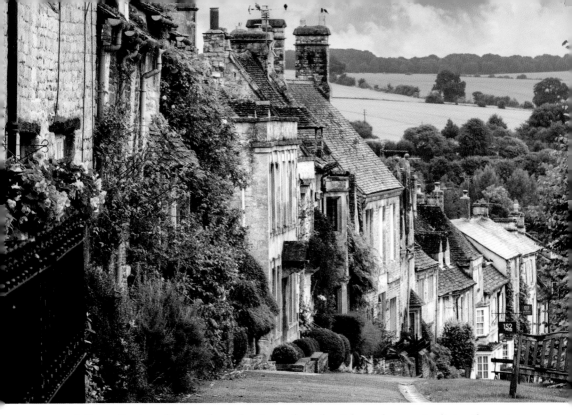

A fine collection of houses from the sixteenth to the eighteenth centuries lining the main street of Burford as it dips down the hill to the River Windrush. (Stuart Vallis)

7. Charlbury Railway Station

Charlbury is a small town in the Evenlode Valley on the edge of Wychwood Forest and the Cotswolds. The best way to approach it is by train, because its station is an absolute delight. The Oxfordshire, Worcester and Wolverhampton Railway opened the station in 1853. The original building is a wooden chalet structure in the Italianate style built by Isambard Kingdom Brunel. It consists of a single storey with a central waiting room, Stationmaster's Office, and Ladies Waiting Room. The three bays have overhanging eaves on moulded brackets which form an attractive and useful canopy over the platform. There are contemporary benches with buttoned leather upholstery, and the original station name board boasts the typical Great Western Railway bold sans serif lettering. It is one of the last surviving 'roadside' station buildings designed by Brunel, and it makes a very elegant and atmospheric way to arrive at the pretty town of Charlbury. You can easily catch a train from Oxford that will take you there on the lovely scenic route to Worcester and Hereford.

It only takes around twenty minutes to travel from Oxford station to Charlbury by train, and there are trains every hour. Improvements were made to what is called the Cotswold Line in 2011, and the second platform at Charlbury, which had been disused for thirty years, was brought back into service. Of course the most romantic way to arrive would be by steam train, and special steam-hauled excursion trains do occasionally run

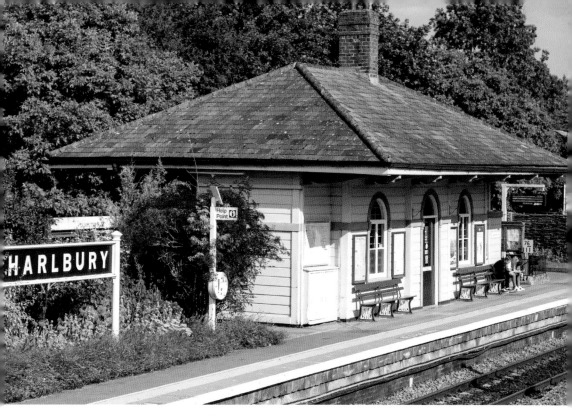

The delightful station at Charlbury, 1853, was designed by Isambard Kingdom Brunel. (Stuart Vallis)

through Charlbury, if you are lucky, hauled by a Great Western Railway Castle Class locomotive of the type which powered most express trains between London, Oxford and Worcester from the mid-1930s until 1964 when diesel locomotives took over.

Having alighted, it is only a short walk up into the town, which boasts the fine thirteenth-century church of St Mary the Virgin, the Charlbury Museum, the Rose and Crown Inn, and the Charlbury Deli and Café. The area also hosts an annual Beer Festival.

8. Chastleton House

At the northernmost tip of the county is one of the finest Jacobean mansions in England, Chastleton House, now in the care of the National Trust. It stands on a hillside, with the little church standing next to it. Inside the church there is a Norman font, a Jacobean pulpit, and a brass to Catherine Throckmorton, 1592, with her five sons and five daughters. Her family originally owned the estate, and it was her grandson Robert Catesby, one of the Gunpowder Plotters, who had to sell the house in 1601 to pay for his sedition. The house was then bought by a local wool merchant, Walter Jones, who rebuilt it in the Jacobean style.

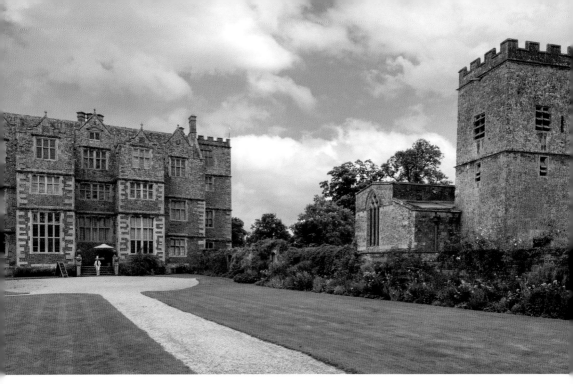

Chastleton House, built *c.* 1605, showing the three-storey frontage and the Church of St Mary the Virgin, with tower of 1689. (Stuart Vallis)

It is built of Cotswold stone around a courtyard with symmetrical gables and staircase towers. Inside, there is a fine oak staircase, a panelled hall, a 72-foot-long gallery with a barrel-vaulted ceiling, and an impressive Great Chamber. The kitchen is blackened with centuries of smoking fires, and hung with pewter plates and bowls. Because it was in the possession of the same family for nearly 400 years, it was carefully conserved by the National Trust and looks much as it did when it was first acquired.

The house was caught up in the conflicts of the English Civil War, when the then owner, Arthur Jones, fought on the Royalist side, and had to flee after Cromwell defeated the Royalists at the Battle of Worcester in 1651. He galloped back to Chastleton with Cromwell's troops in hot pursuit. His brave and clever wife, Sarah, hid him in a secret room above the porch. Sarah was obliged to put up the troops for the night, and although they found Arthur's exhausted horse in the stables they couldn't find him. Sarah laced the soldiers' ale with laudanum, and while they slept, saddled a horse and helped her husband escape.

The gardens are laid out in a formal style, contemporary with the house, the plan conforming to the ideas of Gervase Markham in his book *The English Husbandman* (1613), i.e., a series of courts, including stables, and gardens which included a kitchen garden, an orchard and a pleasure garden.

To the north are terraces, the middle ones being a croquet lawn, first laid out in the 1860s. This ancient game had been introduced into England in 1852, and the rules of the game were drawn up by Walter Whitmore-Jones and published in *The Field* in 1865. So Chastleton is considered to be the birthplace of the competitive sport in this country.

Readers may recognise it as one of the locations in the 2015 BBC adaptation of *Wolf Hall* by Hilary Mantel.

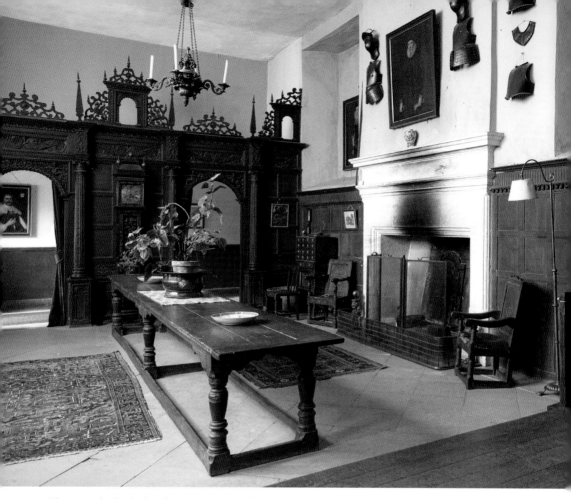

The main hall of Chastleton House, with a screens passage, stone fireplace and panelled walls. (Stuart Vallis)

9. Cogges Farm

Hidden within the unlikely setting of a suburb of the market town of Witney is a delightful group of old buildings beside the River Windrush, comprising the church, manor house and vicarage, with associated farm buildings.

The church of St Mary was begun in the twelfth century, and extended in the fourteenth century, with a new chancel and tower. Inside there is a splendid fourteenth-century stone effigy on a tomb-chest of a female member of the Grey family of Rotherfield, showing her in a wimple and flowing veil with angels at her head and a lion at her feet. There is also a fine Yew Tree in the churchyard and an imposing lychgate.

Cogges Manor was once owned by King Henry VII and then Henry VIII, who gave the land to Thomas Pope, the founder of Trinity College, Oxford. It was owned by a wealthy wool merchant, William Blake, in the seventeenth century, and more recently the manor was owned by the Mawle family, who lived here until 1968.

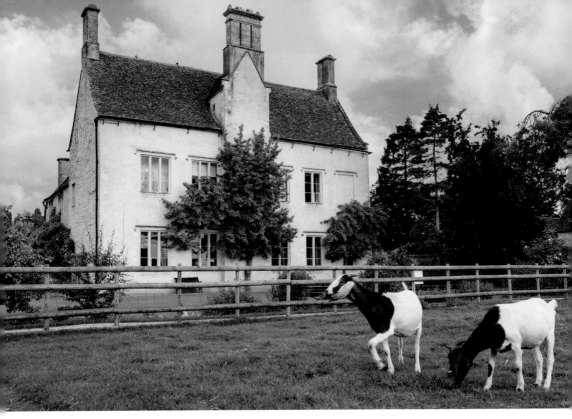

The former Manor Farm at Cogges, an L-shaped house with a hall and kitchen dating from the thirteenth century, now Cogges Farm Museum. (Stuart Vallis)

Manor Farm, south-east of the church, is now the Cogges Farm Museum, retaining old farm buildings and interiors untouched by the twentieth century. The museum houses old farm implements and live animals, including hens, pigs, sheep and goats. It aims to give visitors an insight into farm life, runs workshops for children, and hosts local festivals and theatre performances. It makes a really enjoyable day out, especially for children, where you can see badger setts, feed the chickens, play crocket on the manor house lawn, play in the 'Cogges Castle' timber fort with its own zip wire, and have tea and cake in the Cogges Kitchen Café. The house is a popular location for filming, and was portrayed as the fictional Yew Tree Farm in the long-running TV series *Downton Abbey*.

10. Godstow

Godstow lies on the bank of the River Thames between the villages of Wolvercote and Wytham. An abbey was built here in the early twelfth century, housing an order of Benedictine nuns. The buildings consisted of the nunnery, a guest house, an outer court and a house for a priest, a small chapel and the abbey church itself. After the nunnery was suppressed by King Henry VIII at the Reformation, the buildings fell

into ruin and were largely destroyed in the Civil War. During the nineteenth and twentieth centuries the ruins were used for gathering livestock during the annual round-up of animals on Port Meadow.

The Abbey was the final burial place of the beautiful Rosamund Clifford ('Fair Rosamund'), the mistress of King Henry II, who died *c.* 1176. When Queen Eleanor discovered her at the Royal Hunting Lodge at Woodstock, she fled and retired to the abbey at Godstow, and reputedly died of a broken heart. She was buried in the choir of the church, in front of the High Altar, but Hugh, Bishop of Lincoln called her a harlot and ordered that her remains be removed from the church. Her tomb was moved to the nun's cemetery, but was destroyed when the abbey was dissolved. A German traveller, visiting in 1599, recorded her faded epitaph, a Latin inscription which read: 'Here in the tomb lies a rose of the world, not a pure rose. She who used to smell sweet, still smells – but not sweet.'

The stone bridge over the River Thames is old, the pointed arch next to the Trout Inn being original. The Trout Inn dates from the seventeenth century, and is a well-known destination for eating and drinking, especially on a summer's evening. From this picturesque spot you can see the towers and spires of Oxford across Port Meadow, while nearby are the ruins of the abbey with a fifteenth-century window and arch.

The ruins of Godstow Abbey, a Benedictine nunnery founded in 1133. After the Dissolution of the Monasteries in 1539 it was used as a private dwelling, but burnt down in 1645. (Stuart Vallis)

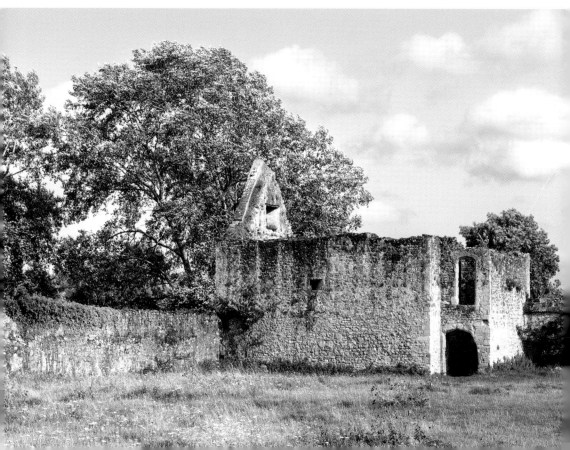

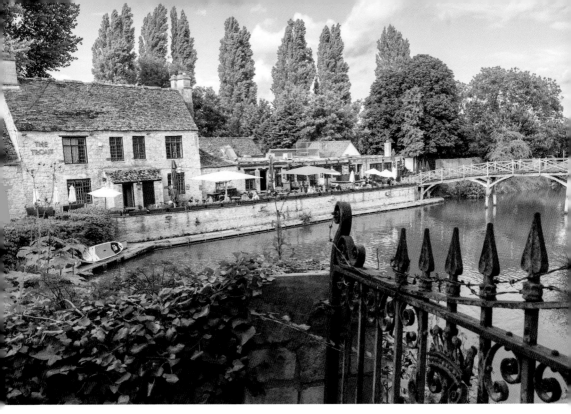

The Trout Inn at Godstow, a seventeenth-century inn by the Thames at the top of Port Meadow. (Stuart Vallis)

11. Hampton Gay

This remote hamlet is full of history and atmosphere. Situated on the banks of the River Cherwell, 'which winds with devious coil round Hampton Gay and Hampton Poyle', it is close to Shipton Church and the Oxford Canal, as well as the Great Western Railway. Professor Nikolaus Pevsner describes it as 'A desolate spot, approached along a cart track. The village has disappeared, and the small church stands in a field between a railway line and the ruins of a manor house.'

The house is the shell of a Jacobean manor house belonging to Wadham College, which burnt down in 1887. It was an E-shaped house with projecting wings. Only the broken-down walls with mullioned and transomed windows remain. In the garden is a gabled summerhouse with an arched entrance. The well-known writer on canals L. C. Rolt described the remains in his book *Narrow Boat*, published in 1944:

> According to an old countryman ... the old house was fired by its last unscrupulous occupant with the object of collecting the insurance money ... Harsh-crying jackdaws had made their habitation in the towering chimney-stacks, crumbling stone mullions gaped in ruin and the charred fragments of

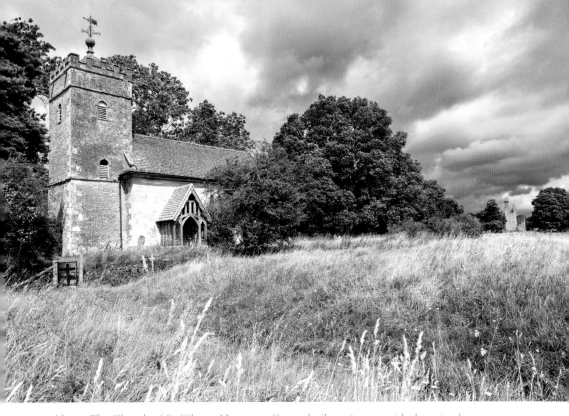

Above: The Church of St Giles at Hampton Gay, rebuilt 1767–72, with the ruined manor house in the background. (Stuart Vallis)

Below: The manor house at Hampton Gay, abandoned after a fire in 1887. The mullioned windows of the sixteenth-century house remain, in a state of pleasing decay. (Stuart Vallis)

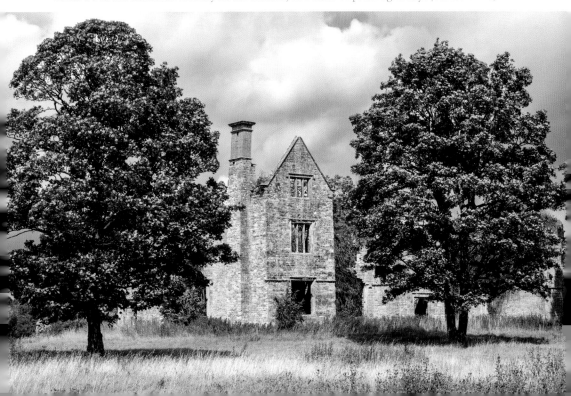

great beams still lay where they had fallen in the nettles that grew thickly within the walls. Yet nature's tireless growth had covered this sorry monument of human greed and violence with a kindly cloak of trees, whose branches swept the walls on every side.

The little church of St Giles, which dates from 1074, was completely rebuilt by the Revd Thomas Hindes between 1767 and 1772. The tower has a fifteenth-century parapet with a pyramid roof and an old bell. Inside there is a fine seventeenth-century wall monument to Vincent and Anne Barry, both kneeling at prayer, he in seventeenth-century armour and she in a black robe and a winged headdress, and accompanied by their daughter Lady Katherine Fenner.

This remote spot with its ruined manor is full of ghosts, a lonely place with an air of sadness, but well worth a visit.

12. Hook Norton

Hook Norton is an attractive ironstone village in the northern part of the county, close to the highest point in Oxfordshire, and straddling the watershed between the Swere, the Cherwell and the Thames to the south, and the Stour and the Severn, which flow westwards to the Bristol Channel. It is a large and thriving parish of just over 2,000 inhabitants, with many buildings of the seventeenth and eighteenth centuries. Traditionally an agricultural community, the railway was opened in 1861 as a branch line from Chipping Norton to Bourton, but was closed in 1964. The cutting is now a BBONT nature reserve.

Tucked away on the western edge of the village, down Brewery Lane, is Hook Norton Brewery with an imposing Victorian façade. The tower brewing building is the finest remaining example in the country. Although during the nineteenth century most towns had their own brewery, most have closed or been taken over by the bigger companies. But Hook Norton Brewery has managed to survive as an independent business, one of only thirty-two family-owned breweries in the country.

In 1849 John Harris set up as a maltster in a nearby farmhouse, and began commercial brewing in 1856, with Brew No. 1, which is described as 'Mild XXX'. On John Harris' death his nephew took over and began an ambitious building programme, including the tower brewery, completed by 1899. On the ground floor a 25-horsepower steam engine was installed, still in use today. The process and machinery for brewing remain much the same as they have done for the past one hundred years. Even the shire horses and drays still deliver supplies within 5 miles of the brewery, and can be seen on most days. In 1999 a new visitor centre was opened by HRH The Princess Royal. New beers have been introduced, a micro-brewery has been started, and their beers continue to win awards.

Above left: The Victorian brewing building of Hook Norton Brewery, 'a pagoda-like building producing fine ales by traditional methods'. (Stuart Vallis)

Above right: One of the shire horses which deliver the beer locally on drays in the traditional manner. (Stuart Vallis)

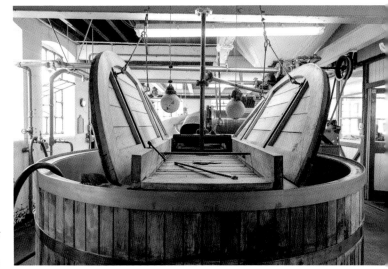

The original mash tun at Hook Norton Brewery in which the barley is soaked in water and heated to break down the starch into sugars, called 'the mash'. (Stuart Vallis)

13. Minster Lovell

The village of Minster Lovell lies in a lovely part of the Windrush Valley 3 miles west of Witney, with stone cottages straggling up the narrow street, and at the top the fine church of St Kenelm looking out over the river valley. I first visited this village in the 1970s to have lunch at the renowned Old Swan, a fifteenth-century inn on the main street, which is now linked with the recently opened Minster Mill, a more modern 5 star complex on the banks of the river.

The name Minster suggests that there was a Saxon minster by the river, and 'Lovell' was added in the thirteenth century, because the Lovell family were the main landholders. In King John's time Maud Lovell founded a priory here, and in the fifteenth century William Lovell built the church and the manor house (1431–32), the ruins of which are now open to the public. The house must have been magnificent in its heyday, but had become a ruin by the time Thomas Coke, who had been created Baron Lovell in 1728, abandoned the hall and partially dismantled it in 1747.

Francis Lovell, the grandson of William Lovell, who built the manor house, was a politically successful but somewhat sinister figure, both in history and in William Shakespeare's play *Richard III*. He served as Lord Chamberlain to Richard III and was involved, along with William Catesby and Sir Richard Ratcliffe, in the King's many dubious schemes to govern his realm. They were lampooned in a verse posted

The Old Swan Inn at Minster Lovell. (Stuart Vallis)

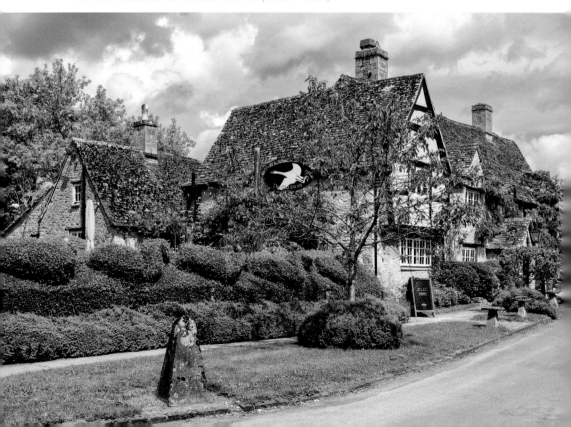

on the door of St Paul's Cathedral in London, because their power was resented by many contemporaries:

> The Cat, the Rat, and Lovell the dog,
> Rule all England under our hog.

Lovell fought at the Battle of Boswell Field, where Richard was killed, and then took refuge in Flanders. In 1487 he came back to take part in the rebellion led by Lambert Simnel, and fought at the Battle of Stoke, after which he fled home and disappeared. There is a legend that he hid himself in a secret room in the house, its whereabouts known only to a trusted servant. The servant died suddenly, and as a result Lovell died of starvation, locked away in the secret room. In 1708, while the house was being repaired and a new chimney built, the hiding place was discovered, with a table and books, and a skeleton bending over them. When exposed to the air, the bones dissolved, and nothing of the body remained. The writer John Buchan used this legend in his novel *The Blanket of the Dark* (1931), set in the time of Henry VIII, and in the countryside west of Oxford during the 1536 Pilgrimage of Grace. He describes Lovell's death in detail, and the eerie atmosphere of the house is such that one of the characters refuses to go near it, 'except in holy company'.

The church of St Kenelm contains the tomb of William Lovell, made of alabaster with carved saints and weepers in the side panels.

14. Great Rollright

In the far north of the county, on the border with Warwickshire near the village of Long Compton, lies a fascinating complex of megalithic stones spanning nearly 2,000 years of Neolithic and Bronze Age history. All constructed from local limestone, there are three distinct sites, known as the King's Men, the Whispering Knights, and the King's Stone, which stands in Warwickshire. The oldest stones are the Whispering Knights, dating from around 3500 BC, probably marking a burial place. Four standing stones survive and create a chamber, which would have been a place of burial and ritual activity for the veneration of ancestors.

The King's Men is a stone circle 33 metres in diameter, comprising seventy-seven stones. Archaeologists now think that when originally erected the stones would have touched each other, creating a continuous barrier, and would have taken a team of around twenty people three weeks to construct. This is just one of many stone circles built across Britain during the late Neolithic period (3500–3300 BC), from the standing Stones of Stenness in the Orkney Islands to similar circles in the Lake District, suggesting that influences from the northern regions gradually spread southwards along trade routes.

The King's Stone (erected *c.* 1800–1500 BC) is a single monolith 2.4 metres tall and originally around 4.5 tonnes, standing 76 metres north of the King's Men.

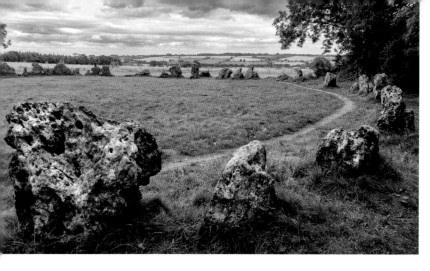

The Kings' Men at Great Rollright, a Neolithic stone circle 100 feet in diameter. (Stuart Vallis)

Archaeologists are uncertain about the function of this stone. Was it part of a long barrow, or an astronomical marker, or a guidepost, or, perhaps most likely, a cemetery marker?

The stones have gained their names from a folktale which describes a king meeting a local witch, who predicted that if he moved forward seven paces and could see Long Compton, he would become King of England. He failed, and was turned into stone, the King's Stone, while his troop of soldiers became the King's Men. Four knights who had been plotting against the king became the Whispering Knights. There is also a legend that as the church clock strikes midnight the King's Stone comes to life. In recent years the site, formerly managed by English Heritage, has become a popular meeting place for Pagan worship. It is now owned and managed by The Rollright Trust, a registered charity, which charges a small sum for entry to the King's Men circle. When you visit you can try counting the stones (harder than you think!), try your hand at dowsing using traditional dowsing rods or a forked hazel stick, and exploring the rich wildlife and plant life at the site.

You can also make up your own mind about whether these haunting stones were originally a religious temple, burial site or hilltop observatory from where our forebears watched the sunrise, or planned the calendar to ensure the corn was sown at the correct season.

15. Shipton-on-Cherwell

When the writer and historian L. C. Rolt made his journey around the canals of England during the Second World War, he left a lyrical description of this little village on the banks of the Cherwell in his book *Narrow Boat*, published in 1944:

> When we had locked through and rounded the bend beyond the lock tail we sighted the grey church and manor house of Shipton-on-Cherwell

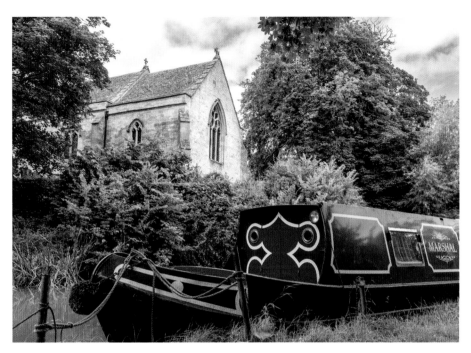

The Oxford Canal and Holy Cross Church at Shipton-on-Cherwell. (Stuart Vallis)

overpeering the water from their vantage on the high right bank, while across the river not a quarter of a mile away stood the tiny chapel of Hampton Gay, dreaming alone in the fields, with only a grass pathway to its door. In the golden evening light the combination of grey buildings, green meadows, tall trees and still, sky-reflecting water made a picture so entrancing that we forthwith decided to journey no further, and moored 'Cressy' where the dry wall of Shipton churchyard sloped down to the water's edge. When I stopped her engine, silence fell swiftly, no breath-bating hush of suspense, but a soundless calm that seemed to lap as closely about us as the water round our hull, and which brought with it a sense of peace unassailable and timeless.

That passage sums up the appeal of this delightful spot, where canal, river and railway run close together. Holy Cross Church stands on an embankment above the canal, a Victorian rebuild on the site of an earlier church. It was built in the Georgian Gothic Revival style by William Turner in 1831. Inside there is a low canopied fourteenth-century recess with a stone coffin. When opened in the eighteenth century a skeleton of a man was found holding a pewter chalice. The churchyard contains the base of a medieval cross. William Turner was a watercolour painter who lived for a time in the manor house next to the church, built in the sixteenth century. In the latter part of the twentieth century the house was owned by the entrepreneur Richard Branson, who used it as a recording studio for Virgin Records, and where albums by Mike Oldfield and Black Sabbath were recorded. It is now a private home.

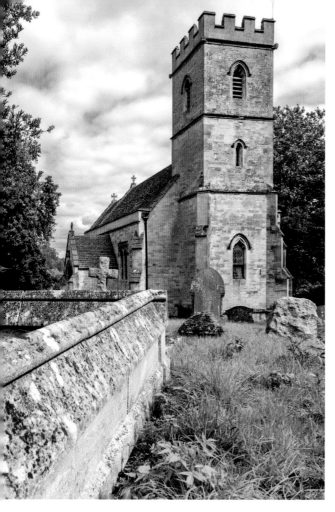

Holy Cross Church, Shipton-on-Cherwell, rebuilt by William Turner of Oxford in 1831 in an early Gothic Revival style. (Stuart Vallis)

16. South Leigh

I have included the village of South Leigh in my fifty gems because of its church, which contains a stunning series of medieval wall paintings. The building dates from the twelfth century, but was extensively altered in the fifteenth century, possibly the work of William Orchard, master mason of Magdalen College, Oxford.

It was during this period that the extensive series of wall paintings was completed, which were only rediscovered in the late nineteenth century. There is a Doom painting over the chancel arch, showing two trumpeting angels waking up those who have died. On one side Saint Peter receives the blessed at the gate of heaven, while on the other the damned, which include kings and bishops, are bound together by a spiked band. A demon urges them with a fork to their doom, a scarlet-headed monster who is waiting to devour them.

By the south doorway Saint Michael, clothed in feathers and brandishing a sword, holds the scales in his right hand for the weighing of souls. At one end of the scales is a seated figure, a demon weighing him down against the efforts of the Virgin Mary

who intercedes for him. She stands on a crescent moon and drops her beads into the scales. The demon blows his horn to summon help, and other demons appear, clinging to the scales. The gates of Hell are wide open, and others look on helpless. Then the scales tip down towards redemption, the intercession of the faithful is triumphant, and the soul is saved.

On the east wall of the chancel is a representation of the Virgin Mary, in red, green and gold, carrying a lily under a rich canopy. Under a similar canopy is Saint Clement of Rome wearing the triple crown and in papal robes. Finally, at the west end of the South Aisle is the Mouth of Hell and the Seven Deadly Sins.

In the medieval period wall paintings had the same didactic purpose as sermons, at a time when neither clergy nor laity were able to read well. These vivid paintings taught the Christian faith, and both warned and encouraged medieval men and women to say their prayers, live pious lives, and to fear the consequences of falling away from the teachings of the church. The South Leigh wall paintings are a striking reminder that even in rural Oxfordshire you had to watch your step!

While in the church have a look at the Jacobean pulpit, because it was here that John Wesley, who founded Methodism, preached his first sermon in 1725.

Below left: Fifteenth-century wall paintings at South Leigh, showing the Last Judgement over the chancel arch, and St Michael Weighing Souls on the south wall. (Stuart Vallis)

Below right: St Clement of Rome under a canopy, a wall painting in the north aisle, South Leigh. (Stuart Vallis)

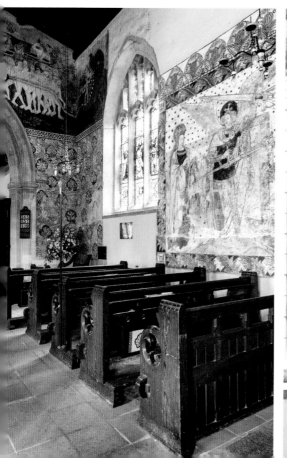
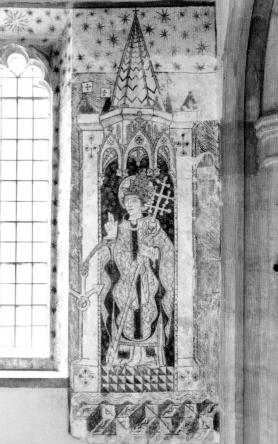

17. Swinbrook and Widford

Around 2 miles from Burford is the idyllic village of Swinbrook, a quintessential bit of Old England, with its church, cricket pitch, stone-built cottages and old inn next to the stone bridge over the River Windrush. In the early twentieth century the village became associated with the Mitford sisters because in 1926 their father, the 2nd Baron Redesdale, moved from Asthall and had Swinbrook Hall built nearby. Four of his daughters are buried in the churchyard of St Mary the Virgin – Nancy, Unity, Diana and Pamela. Nancy disliked the house so much that she called it 'Swine Brook'.

The church stands on a rise, and dates from around 1200. It's chief glory is the extraordinary Fettiplace monuments in the chancel. Six generations of the Fettiplace family recline on their stone shelves, 'like merchandise in a shop' (Pevsner). In their heyday the Fettiplaces were amongst the greatest landowners in Oxfordshire and Berkshire, but in the eighteenth century the four brothers died childless, and the family disappeared from history. Nothing is left of their medieval manor house, once the finest in Oxfordshire. We are left with this wonderful series of monuments, which take up nearly the whole of the north wall of the chancel. There are two monuments, one with three Tudor gentlemen lying on three shelves, stiffly, in armour, one above the other, all resting their heads in their hands, with their elbows on cushions. This was built by Sir Edmund Fettiplace, 1613, and represents himself, his father and grandfather. Next to them are three Stuart Fettiplaces resting on shelves of black marble. This is a more

St Mary's, Swinbrook, with its nineteenth-century tower, decorated south porch and old slate roofs. (Stuart Vallis)

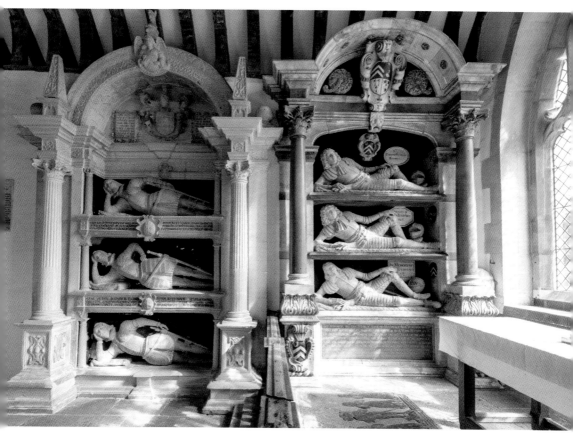

The splendid Fettiplace monuments at St Mary's, Swinbrook, which fill the north wall of the chancel and date from the seventeenth century. On the floor are the brasses of John Croston, 1470, and his three wives. (Stuart Vallis)

sophisticated work by the sculptor William Bird of Oxford, built by another Edmund Fettiplace, 1686, to commemorate himself and two ancestors. The effigies look more relaxed and natural, lying under an arch supported by Corinthian columns. A truly unusual and engaging sight in this lovely little church, which I remember visiting one Easter Sunday around sixty years ago, when the church was full of daffodils and spring flowers, and the vicar rushed happily around doing everything from leading the service to playing the organ, to ringing the bell. In the churchyard there are a number of so-called 'bale' tombs, the rounded tops possibly symbolising a bale of wool, or a woollen shroud, and dating from the seventeenth and eighteenth centuries.

The former mill is now the Swan Inn, just by the charming bridge over the river, and owned by the Chatsworth Estate. It was the setting for Lady Sybil's elopement with the family chauffeur in the TV series *Downton Abbey*, and also the pub in which Prime Minister David Cameron entertained the French Premier Francois Hollande in 2014.

If you have time it is well worth walking along the footpath from Swinbrook that leads across river meadows to the tiny hamlet of Widford, and the medieval

The nave of St Oswald's Church, Widford, showing the early nineteenth-century box pews, Jacobean communion rails and Commandment Boards. (Stuart Vallis)

church of St Oswald, hauntingly beautiful with box pews and wall paintings, and a Norman font. Under the church are the remains of a mosaic floor from a Roman Villa.

18. Great Tew

This is a gem of a village, tucked away in the northern part of the county, set in a narrow valley where the hills descend steeply, through which a tributary of the River Cherwell, the Worton Brook, flows.

The village of Great Tew was designed as an estate village in the nineteenth century, part of the Great Tew Estate which covers 3,500 acres north-east of Chipping Norton. After passing through several hands the estate was inherited by Lucius Cary, the 2nd Viscount Falkland in the seventeenth century. He made many improvements before he died in the Civil War at the Battle of Newbury in 1643. The estate changed hands again before being acquired by Matthew Boulton in 1815, who put in hand a huge programme of building works and improvements to the village. The estate was again rescued by Major Eustace Robb in the 1960s and now belongs to the Johnston family. The manor house, which had become derelict, was bought in 2014 by media tycoon Rupert Murdoch, and his wife Jerry Hall.

Cottages in Great Tew. Pevsner describes the village as 'unforgettable, with thatched cottages engulfed in gardens in a valley encircled by trees'. (Stuart Vallis)

The village descends down the hillside in a line of picturesque thatched cottages, built of stone with thatched roofs. At the top of the hill are the church and manor house. The church of St Michael has a good Perpendicular font, rood screen and stairs, old pews and a good collection of monuments and brasses. There is a fine Norman doorway in the porch.

In 1809 the gardener J. C. Loudon planted many trees around the village, giving it a leafy, park-like appearance, which is most attractive. There is a good local inn, the Falkland Arms, a late seventeenth-century building with flagstone floor and inglenook fireplace, which serves meals and holds a Michelin star.

19. Thrupp

In AD 1086 Thrupp was such a small settlement that the Domesday Book did not record any people living there. Today it is still a small hamlet, but because of the building of the Oxford Canal, which in 1788 was extended south towards Kidlington, it is now a charming spot with the canal wharf, café and local pub The Boat Inn, bustling with boating activity in the summer.

The canal basin and boatyard offices on the Oxford Canal at Thrupp. (Stuart Vallis)

The Oxford Canal links Coventry with Oxford, and in the nineteenth century was an important route for coal, iron and stone. The coal trade declined in the 1950s, but the canal has become an important leisure resource for many who live on the canal boats or those who hire them for holidays. At Thrupp the canal turns away from the River Cherwell at a right angle and follows the River Thames into Oxford. On the bend of the canal lies Thrupp Wharf, an attractive group of buildings with a lift-bridge, and further along a pretty row of picturesque cottages originally built by the canal company. Part of the original British Waterways boatyard has become Annie's Tea Room, which serves delicious coffees, lunches and teas seven days a week. Further along the towpath is The Boat Inn, which has been serving the waterway for several hundred years, and providing liquid refreshment for generations of boatmen. It is a great place for a pint and serves a wide range of meals and bar snacks.

Beyond the Thrupp canal yard there is a railway bridge, and nearby a map showing a number of footpaths across the community woodlands. This bridge was the scene, nearly 150 years ago, of a terrible railway accident in December 1874, when a train from Oxford to the Midlands, full of passengers on Christmas Eve, left the rails and plunged down the embankment beside the Oxford Canal, some of the carriages ending up in the icy waters. With thick snow on the ground, rescue conditions were difficult, and help was slow to arrive. Eventually a special train from Oxford brought assistance and medical supplies. Thirty passengers died, and over 100 were injured in what was the worst railway accident of the period. Lord Randolph Churchill attended, bringing supplies of food, and Queen Victoria sent a message of sympathy.

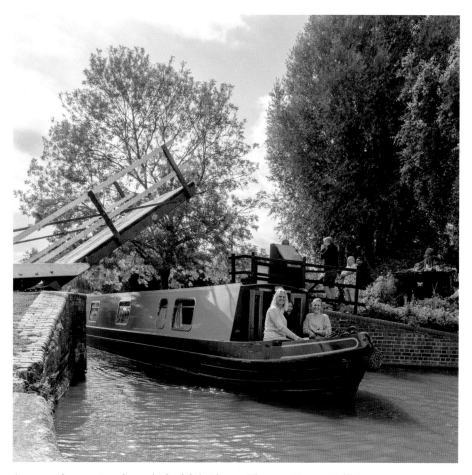

A narrowboat going through the lift bridge at Thrupp. (Stuart Vallis)

20. Wychwood Forest

Once upon a time, hundreds of years ago, much of England was covered in thick forest. Today most has disappeared, but occasional traces remain. Wychwood Forest once stretched from Great Rollright to Woodstock, and was at the time of the Norman conquest one of four royal hunting grounds in England. It survived the land enclosures of the nineteenth century, but is now confined to a few square miles between Ascott-under-Wychwood, Leafield and Charlbury. John Piper in his *Shell Guide to Oxon* called it 'tangled, tousled, curious and remote'.

By 1300 a royal hunting lodge had been built at Woodstock, and Henry I erected a lodge at Cornbury Park, now an estate of 1,700 acres owned by the Lord Rotherwick. It was the original venue for the Cornbury Music Festival and the Wilderness Festival.

Wychwood Forest is the setting for one of John Buchan's novels, *The Blanket of the Dark* (1931), the action of which takes place at the time of the Reformation in the sixteenth century. Peter Pentecost is a clerk at the Abbey of Osney, frustrated with his life, but stirred into action when he discovers he is a descendant of Edward III, and the legitimate King of England. Instead of fighting for the crown that is rightly his, he turns his back on worldly success, and seeks a different world in the heart of the forest. The book is John Buchan's homage to an Old England symbolised by the forest and those who live in it.

Wandering along the paths of Wychwood Forest today you can capture something of that ancient magic and mystery which stirred John Buchan. Part of the forest is a National Nature Reserve, which preserves many species of wild flowers and ferns. The Wychwood Way is a 37-mile circular trail around the heart of the ancient forest, starting from Woodstock, or you could try a shorter walk, starting from the splendidly named Ascott d'Oyley, and going via Kingstanding Farm, Stag's Plain, and Chilson back to your starting point, and finishing at the Swan Inn near the railway station at Ascott-under-Wychwood for a welcome pint of ale and tasty food.

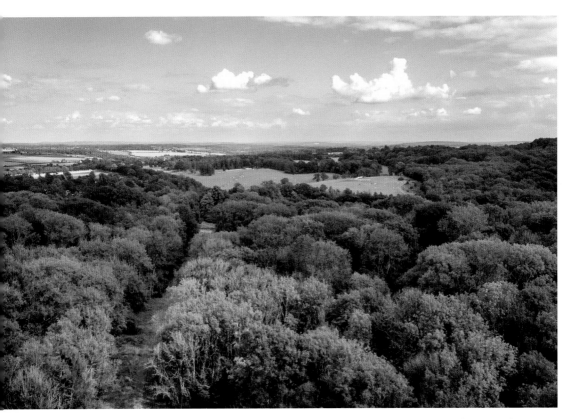

An aerial view of part of the ancient Wychwood Forest, at one time one of the royal hunting grounds of England. (Stuart Vallis)

21. The Ashmolean Museum

Elias Ashmole was a seventeenth-century antiquary, collector and student of alchemy, with a strong interest in the natural world. His own library and collection was considerably expanded when in 1659 he took over the collection of curiosities amassed by John Tradescant, the seventeenth-century royal gardener, which had been expanded by his son to include items from the New World. In 1683 Ashmole bequeathed the entire collection to the University of Oxford, where it was housed in a purpose-built museum in Broad Street, now the Museum of the History of Science.

Amongst the original items are Guy Fawkes' lantern, Oliver Cromwell's death mask, a piece of the stake at which Bishop Latimer was burned, Henry VIII's stirrups, and the mantle of Powhatan, the father of Pocahontas. There is also a collection of ancient marble bequeathed by John Seldon in 1654, and there is further archaeological material from Egypt and Crete. For 200 years the building in Broad Street, designed by Christopher Wren, housed the collections, and then in 1841–45 a new building, designed by Charles Cockerell in the classical style, was built on the corner of St Giles and Beaumont Street. Because of its origins it is the oldest museum in Britain, and the second oldest in the world.

The lower floors of the museum are devoted to objects and sculpture from the ancient world, while there are displays of art and paintings on the upper levels, including Old Masters, seventeenth-century pictures from the Low Countries, sketches by Van Dyck, drawings by Michelangelo and Raphael, and Pre-Raphaelite and Impressionist works.

In 2009 the museum underwent a major redevelopment which greatly expanded the exhibition space and increased the number of floors to five, creating a dedicated space for special exhibitions. You can spend time visiting some of the highlights of the collection, which include the Alfred Jewel, paintings by J. M. W. Turner, the Messiah Stradivarius violin, the Arab ceremonial dress owned by Lawrence of Arabia, the Abingdon Sword, and a large collection of Egyptian, Greek and Roman antiquities.

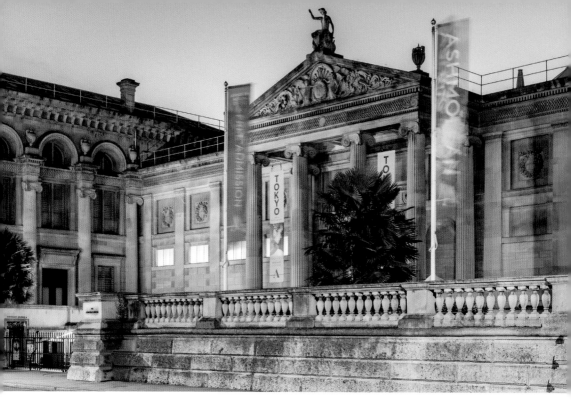

The Ashmolean Museum, Oxford, designed by Charles Cockerell and built in 1841–45, showing the central portico of Ionic columns and at the top of the pediment a sculpture of the seated figure of Apollo. (Stuart Vallis)

22. Blackwell's Bookshop

No visit to Oxford is complete without a visit to Blackwell's bookshop opposite the Sheldonian Theatre on Broad Street. It is one of the world's most famous bookshops, founded in 1879 by Benjamin Blackwell and run by the family ever since.

Benjamin Blackwell was the son of the first city librarian, and at the age of thirteen was apprenticed to a local bookseller. The original bookshop on Broad Street was only 12 feet square, but gradually expanded, swallowing up the neighbouring shops. Benjamin's son Basil joined the firm in 1913, presiding over the company for over sixty years, and expanding the business considerably. When I was an undergraduate in the 1960s I had an account at Blackwell's and can remember seeing old Sir Basil walking around the shop. In 1966 a vast basement area was opened, called the Norrington Room, extending under part of Trinity College, boasting 3 miles of shelving, and at 10,000 square feet it was the largest book-selling area in the world.

The shop stocks a huge range of books, as befits an academic bookseller in a university town, and on the second floor you will find Blackwell's Rare Books, which sells collectable books, modern first editions, and private press and antiquarian books on subjects ranging from architecture to topography to medicine.

Book buying and collecting is a kind of disease, and I happily confess that I am an incurable sufferer. I have more books at home than I have shelf space for, and a

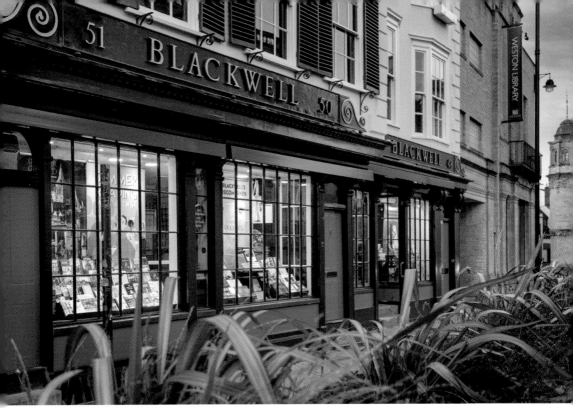

Above: The frontage of
Blackwell's bookshop on Broad
Street, founded by Benjamin
Blackwell in 1879. (Stuart Vallis)

Right: A quiet corner of
Blackwell's bookshop, with
pictures of the Blackwell family
above the mantlepiece. (Stuart
Vallis)

visit to Blackwell's, which now also includes an attractive coffee shop, is always a temptation to add to them. I agree with what Winston Churchill once said:

> If you cannot read all your books, fondle them, peer into them, let them fall apart where they will, read from the first sentence that arrests the eye, set them back on the shelves with your own hands, arrange them on your own plan so that you at least know where they are. Let them be your friends: let them, at any rate, be your acquaintances.

23. The Botanic Garden

In July 2021 the Oxford Botanic Garden celebrated its 400th birthday. The oldest of Britain's botanic gardens, it was founded in 1621 by Henry Danvers, Earl of Danby, as a physic garden for growing herbs and plants for use in medicine and science. Created on the site of the city's Jewish cemetery, Danvers leased the ground from Magdalen College, and by 1642 the garden was established, looked after by the first keeper, Jacob Bobart the Elder, a former soldier from Germany.

Much of the original layout has survived, consisting of a series of rectangular beds covering around 5 acres, surrounded by 14-foot-high walls. The fourth side on the High Street was enclosed by laboratory buildings and a triumphal arch designed by Nicholas Stone in 1632 in the Baroque style as the main entrance. At the far end of the central path a large yew tree was planted in 1650.

One of the eighteenth-century botanists, John Sibthorp, made journeys to the Mediterranean in 1784 and 1794, collecting plants which he brought back to Oxford, and which were beautifully recorded in a book called *Flora Graeca*. By the 1830s the garden was formally named the Botanic Garden, and it now contains over 5,000 different plant species, used for research and conservation.

A new garden, created in 1944, contains a lily pond, a bog garden and rockeries, and another area is planted with roses. Glasshouses near the River Cherwell hold a further range of plants, including ferns, palms and lotuses. The south-west corner of the garden is home to the medicinal plant collection, used to treat conditions ranging from heart complaints, blood disorders and skin diseases to diseases of the nervous system. To celebrate the 400th anniversary a new rose has been created, the Oxford Physic Rose, and in addition to its own brand of gin a special whisky has been launched.

The gardens are a wonderful oasis of tranquillity in the heart of Oxford, and have been a source of inspiration for a number of writers, including J. R. R. Tolkien, Philip Pullman, and Colin Dexter. The garden's water-lily house can be seen in the background of Sir John Tenniel's illustration of *The Queen's Croquet-Ground* in Lewis Carroll's *Alice's Adventures in Wonderland*, and Lord Sebastian Flyte, in Evelyn Waugh's *Brideshead Revisited*, takes Charles Ryder 'to see the ivy' in the Botanic Garden soon after they first meet.

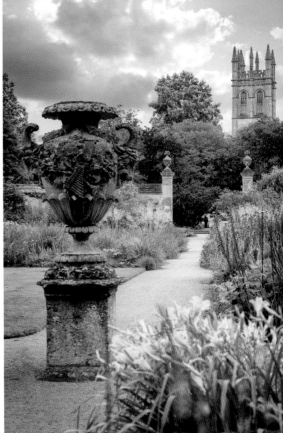

Above left: The Botanic Garden, founded by Henry Danvers, Earl of Danby, in 1621. (Stuart Vallis)

Above right: One of the main avenues in the Botanic Garden, with the tower of Magdalen College in the background. (Stuart Vallis)

24. The Cherwell and Punting

Oxford is surrounded and penetrated by numerous waterways, a great feature of the city and the reason for its existence, where oxen crossed the ford (Oxon-ford). The River Cherwell is a tributary of the River Thames, rising in the ironstone hills west of Charwelton, and flowing 40 miles to meet the Thames at Oxford. On the northern outskirts of Oxford it passes the Victoria Arms at Marston, a popular punting destination, Wolfson College, the Cherwell Boathouse (where punts can be hired) and runs on by the University Parks, after which it splits into three streams, flowing past St Catherine's College and Magdalen College. Two of the streams join up again to flow under Magdalen Bridge, and the main stream skirts Christ Church Meadow before joining the Thames.

You can hire a punt or a rowing boat at either Magdalen Bridge or the Cherwell Boathouse (accessed via Bardwell Road), and enjoy the pleasure of a leisurely trip

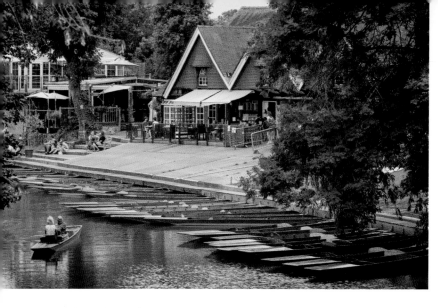

The Cherwell Boathouse, built in 1904, now a popular punting station and restaurant. (Stuart Vallis)

along the leafy and blossom-laden stretches of the river. A punt is a flat-bottomed boat with a square-cut bow, originally used by watermen for fishing and ferrying, using a long pole with which you push the punt along, standing in the well at the stern of the craft, according to the Oxford tradition.

Jerome K. Jerome, in *Three Men in a Boat* (1889), says: 'Punting is not as easy as it looks. As in rowing, you soon learn how to get along and handle the craft, but it takes long practice before you can do this with dignity and without getting the water all up your sleeve.'

In spite of this, it is well worth having a go yourself, and each punt is provided with a paddle in case more assistance is needed.

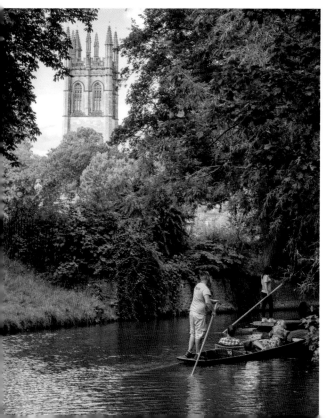

Punting in Christ Church Meadows on a summer's afternoon. (Stuart Vallis)

25. Christ Church College, Oxford

Christ Church is the grandest, and largest, of the Oxford colleges, with the unique distinction of having a college chapel that doubles as the cathedral for the Diocese of Oxford.

It was built on the site of a priory founded by St Frideswide in AD 730 (see the entry for BINSEY), and then refounded by Augustinian canons in the twelfth century. It grew and prospered until Cardinal Wolsey dissolved it in 1525 and founded Cardinal College on the site, intending to outdo all the other colleges in splendour. When he fell from grace King Henry VIII took over the college and refounded it in 1532. When Oxford was made a separate diocese the chapel was elevated to the status of a cathedral and the whole college was renamed Christ Church in 1546.

Christ Church also has the advantage of facing onto Christ Church Meadow, a large fenced-off area of countryside which protrudes right into the city, and which is

A distant view of Christ Church, with Tom Tower and the spire of the cathedral, from Christ Church Meadows. (Stuart Vallis)

home to a herd of long-horned cattle. There are delightful walks along the tree-lined New Walk which leads to the River Thames, and along Broad Walk from where you get fine views of the college skyline. At the top of the New Walk is the new visitor centre and shop, and Longhorn Café, where you can buy your entry ticket for the college. The entrance for tourists is now the Meadow Gate, from where a short walk brings you to the cathedral cloisters, dating from the fifteenth century, and most of which were demolished by Wolsey to make way for Tom Quad.

When you enter the cathedral you may feel a little disappointment because of its small size. However it is full of interesting features. In the enlarged north aisles you will find the shrine of St Frideswide, a nineteenth-century reconstruction with a carved canopy depicting the legend of St Frideswide. There is some wonderful stained glass by Edward Burne-Jones in the Latin Chapel, and in the chapel to the south of the choir, a curious sixteenth-century watching loft by the shrine, a number of medieval and Victorian memorial brasses, and many wall tablets to university academics.

On leaving the cathedral you can mount an impressive staircase which leads to the college hall, the largest in Oxford, with a magnificent Tudor hammer-beam roof, and immortalised as Hogwarts Hall in the *Harry Potter* films. There are many portraits of famous people hanging from its walls, including a portrait of founder Henry VIII above the High Table.

Apart from its more recent *Harry Potter* associations, the literary character most associated with Christ Church is Charles Dodgson, who came to Christ Church as

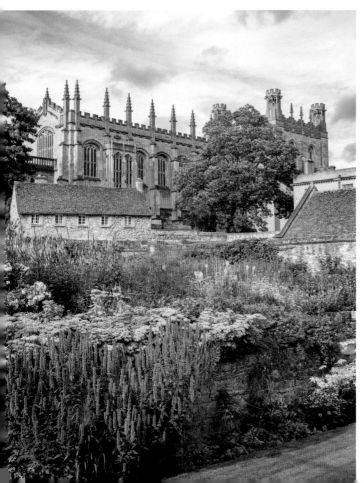

The Great Hall of Christ Church, which became Hogwarts Dining Hall in the Harry Potter films.

an undergraduate in 1851, and was then appointed a lecturer in mathematics. In 1856 he first met Alice, the daughter of the Dean, Henry Liddell, the young girl who inspired perhaps the most famous children's stories of all time, *Alice in Wonderland* and *Alice Through the Looking Glass*. He chose as his pseudonym 'Lewis Carroll', and amused himself by writing the stories to please the Dean's three daughters. You can see the front door of the Deanery in Tom Quad, and inside the cathedral a small door at the western end of the nave gives you a glimpse of the Dean's Garden, where there is an old horse chestnut tree often identified as the one where the Cheshire Cat first appears to Alice. The visitor route takes you past the Deanery, under the archway and through Peckwater Quad, built in the classical style in 1713, with the imposing Library, completed in 1772, and on into Canterbury Quad. Here is the entrance to the Christ Church Picture Gallery which houses the college's impressive collection of Old Master paintings and drawings, one of the most important private collections in the country.

26. The Covered Market

In the centre of Oxford, between the High Street and Market Street, is a large area known as the Covered Market.

It was established in 1774 as a home for the many stallholders who filled the streets of Oxford, and for many years it used to be full of butchers, fishmongers, fruit and vegetable stalls, delicatessens, and florists, all serving the needs of the colleges and hotels of the city. Now their supplies are sourced from wholesalers, and only a handful of food retailers remain.

The building was designed by John Gwynn, an eighteenth-century architect and engineer who also designed Magdalen Bridge. He was a friend of Dr Samuel Johnson. For the best view of the exterior stand opposite the High Street entrances. After 1773 it was decreed that meat was to be sold only inside the

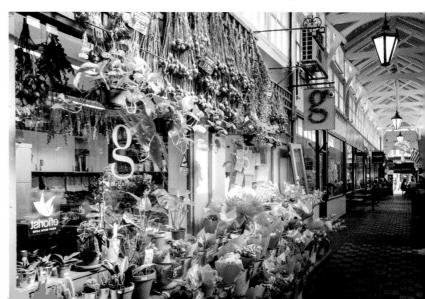

The interior of the Covered Market, Oxford. (Stuart Vallis)

market, and from this time other stalls proliferated. John Betjeman remarked, 'The market has a Georgian air and one somehow feels that the things one buys here must be better than those displayed in the more flashy shops of the main streets.'

Once a year two Clerks of the Market are sworn in at the first meeting of the University Congregation, the last relic of the control the university once exercised over the town.

There is now a link through to Golden Cross Yard, originally part of the Golden Cross Inn, which may have existed on this site since AD 1193. The Golden Cross includes the chamber in which Bishops Ridley and Latimer were cross-examined in 1555 while imprisoned at the nearby Bocardo Jail.

Today the market is home to a wide variety of independent traders, including boutique clothes shops, Cardews & Co. specialist tea and coffee emporium, florists, a bakery, a jewellers, the Oxford Cheese Company, the legendary Brown's Café, and other specialist outlets.

27. The High Street

This long, gently curving street, stretching from Carfax Tower down to Magdalen Bridge, is one of the great thoroughfares of the world. The road originally led, beyond the East Gate, marked today by the hotel of the same name, to a crossing point of the River Cherwell. Over the centuries shops, inns and colleges have been built along its length, giving it an air of bustle and elegance as the main street of the city. In the eighteenth and nineteenth centuries coaches would bowl up the High to one of the many inns, of which the Mitre is the only survivor today.

The beauty of the street is best appreciated in the early morning in summer, before it gets clogged with buses and delivery vans. From the Magdalen end you pass the Examination Schools, Queen's College, University College, All Souls College, Oriel College, and the University Church of St Mary the Virgin, which flanks Radcliffe Square. There are splendid views of the central area of Oxford from the top of the church tower. You can see how the High curves away east towards the River Cherwell, the tower of Magdalen College, and to the west the domed top of Christ Church's Tom Tower.

As well as the colleges there are some interesting shops, including the tailors Ede and Ravenscroft at No. 119, Shepherd and Woodward, the University outfitters, Sanders of Oxford (fine prints) at No. 104, Brora (women's cashmere clothing) at No. 102, Plus Pens (Fine stationery and pens) at No. 69–70, and Reginald Davis (silversmiths) at No. 34. At No. 84 High Street Frank Cooper began selling marmalade made by his wife, which has become famous as 'Oxford Marmalade'. For an excellent lunch or dinner you can't do better than Quod Restaurant and Bar, part of the Old Bank Hotel, which has a delightful Italian garden terrace for al-fresco dining.

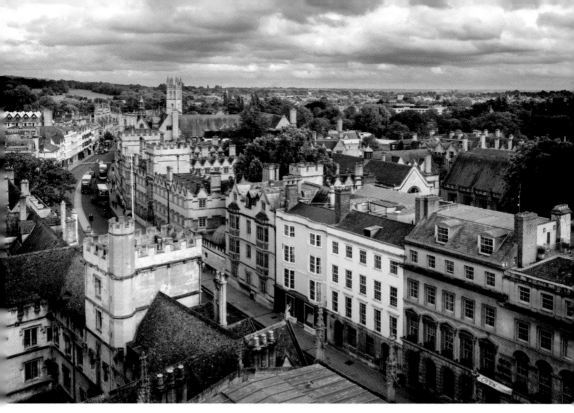

A view of the High Street, curving away to Magdalen Bridge, from the tower of St Mary the Virgin. (Stuart Vallis)

28. Keble College

Architecturally unlike any of the other colleges, Keble College is an assault on the eyes, an enormous brick building that looms above those walking along Parks Road. It stands opposite the University Museum and the Parks, and was founded in 1868 as a memorial to the Revd John Keble, who in 1833 preached a famous sermon on national apostasy, which launched what became known as the Oxford Movement. This movement was led by Keble, John Henry Newman and others who wanted the Church of England to reclaim its Catholic inheritance and free itself from state interference. The Revd John Keble became Vicar of Hursley in Hampshire in 1836 and remained there for the rest of his life, becoming well known and loved for his poetry and hymn writing. He died in 1866, and it was decided that his memorial would be a new Oxford college bearing his name.

The architect chosen to design the new buildings was William Butterfield, who designed the college in red brick with a riotous use of white and blue patterned banding. Built in his signature polychromatic High Victorian style, Keble is one of the largest colleges in Oxford, with vast quadrangles and a sunken lawn that accentuates the height of the enormous chapel rising 90 feet in height, funded by the Victorian businessman William Gibbs at a cost of £50,000, and full of

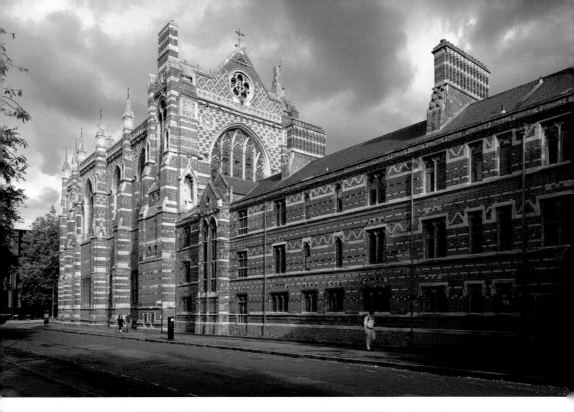

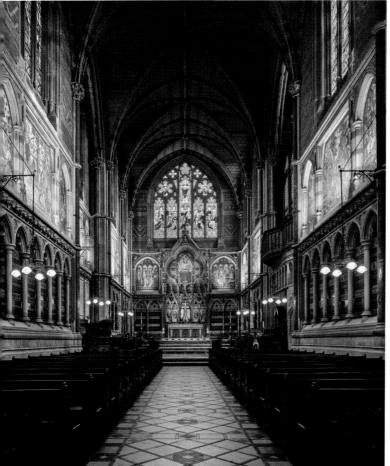

Above: The exterior of Keble College, designed by William Butterfield, on Parks Road. (Stuart Vallis)

Left: The interior of Keble College Chapel, designed by William Butterfield, with stained glass and mosaics by Alexander Gibbs.

mosaics and stained glass. Holman Hunt's famous painting *The Light of the World* hangs in a side chapel. He painted it when he was in his twenties after emerging from a bout of severe depression. The picture was exhibited at the Royal Academy and was bought for £400 guineas by the Printer to the University, Thomas Coombe, whose widow presented it to the college. The story is told that Hunt was so angry when he learnt that the college was charging visitors to see the painting that he painted a copy and gave it to St Paul's Cathedral in London, where it can still be seen.

The hall is one of the largest in Oxford, with traceried windows and a wagon roof, and is 127 feet in length.

29. Magdalen College

Arriving in Oxford from the east, as you come over Magdalen Bridge the first thing you see is the handsome tower of Magdalen College, 'singularly venerable', as Thomas Babington Macaulay said. Founded by William of Waynflete, Bishop of Winchester, in 1458, Henry VI's Lord Chancellor took over the ruined Hospital of St John, a medieval infirmary and hall where travellers could stop for the night or ask for food.

In St John's Quadrangle is the fifteenth-century outdoor pulpit where a sermon is preached once a year in June. The fifteenth-century chapel is large and impressive, with a nineteenth-century reredos, much stained glass in the ante-chapel, and a fine collection of memorial brasses to former members.

The impressive Bell Tower was begun in 1492 and completed in 1505, rising 150 feet above street level. Every year on May Morning choristers assemble at 6 a.m. at the top of the tower to welcome the beginning of May in song, ending with the Te Deum and the Grace.

The large block called 'New Buildings', completed in 1733 and originally intended as part of a vast new quadrangle until the money ran out, stands in the meadows at the back of the college, where there is also a massive plane tree planted in 1801. Across a bridge over an arm of the River Cherwell is Addison's Walk, named after the eighteenth-century essayist Joseph Addison, who loved to walk beside the River Cherwell. It is a delightful tree-lined path running along the top of a causeway created from the remains of King Charles I's Civil War defences. The walk leads you on a circular route for around a mile around the water meadows, where there is a rich abundance of flora and fauna, including the rare snake's head fritillaries which create a carpet of magenta-purple amongst the surrounding woodland. Oxford writer C. S. Lewis, a Fellow of Magdalen College, would often walk here with his friend J. R. R. Tolkien. It inspired him to write the poem *What the Bird Said Early in the Year*, which includes the lines:

I heard in Addison's Walk a bird sing clear:
This year the summer will come true – This year. This year.

Left: The tree-lined Addison's Walk, part of Magdalen College. (Stuart Vallis)

Below: The bridge connecting Addison's Walk to the main part of Magdalen College. (Stuart Vallis)

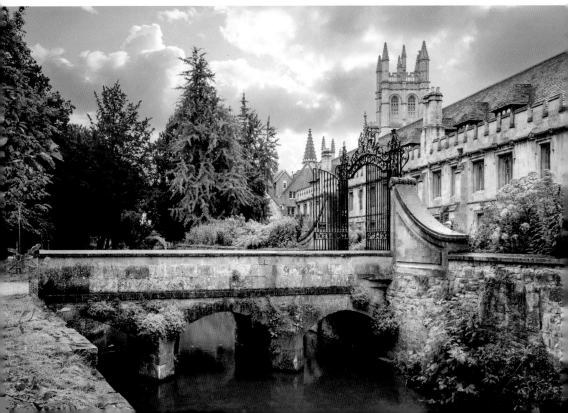

30. Oxford Castle and Prison

Beyond the modernised Westgate shopping centre lies Oxford Castle, a Norman castle with a rectangular St George's Tower which may date from Saxon times. In 1071 William the Conqueror granted lands to one of his barons, Robert d'Oyly, and ordered him to build a castle to defend Oxford. d'Oyly diverted a stream of the Thames to produce a moat and built his castle to the west of the town, which included towers, and a chapel with a crypt. In 1142 Empress Matilda took refuge in the castle trying to gain the English throne from Stephen, who was laying siege to the castle. In the depths of winter she managed to escape down the River Thames before Stephen finally took the castle. In the thirteenth century King Henry III turned part of the castle into a prison, to control troublesome elements of the university, but by the mid-fourteenth century the castle was in a state of disrepair, as it was of little military use, and so it became the town gaol, criminal court, and administrative centre for Oxford.

During the English Civil War in 1642 the Royalists were besieged in Oxford and the castle was reinforced, but after the Civil War, it became a prison again. By the eighteen

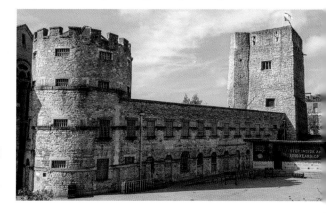

Right: Oxford Castle and Prison, showing the thirteenth-century tower of the castle and former prison buildings, 1848–56.

Below: The crypt of the former Chapel of St George, originally founded by Robert D'Oyly. Short round piers with big capitals support a low ceiling.

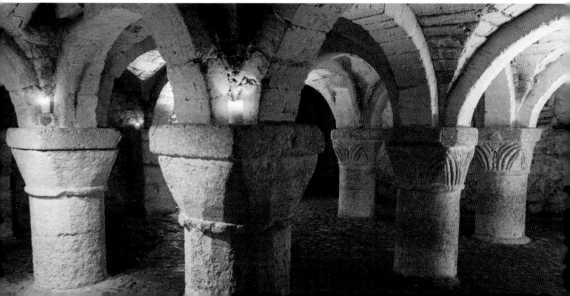

century it was in such a poor state that it was decided to rebuild it. In the nineteenth century further buildings were added, including County Hall in 1840–41, the Oxfordshire Militia Armoury in 1854, and further extensions to the prison in 1876. H. M. Prison Oxford was finally closed in 1996, and the site has been redeveloped as a tourist attraction, including a restaurant, shops, and heritage complex, and a Malmaison Hotel which occupies a large part of the former prison block, with cells converted into guest rooms.

31. Radcliffe Square

Visitors to Oxford often ask, 'But, where is the University?' The proper answer is 'Everywhere: it is all around you in Oxford.' But if you want to see a group of buildings that are at the heart of the university and reveal a real sense of its long history, then you can't do better than visit Radcliffe Square, where you will see clustered together the University Church of St Mary the Virgin, Brasenose College, the Bodleian Library, Hertford College, All Souls College, and the Radcliffe Camera, surmounted by its great dome, and standing in the middle of the whole ensemble. The Camera and the Square are named after Dr John Radcliffe, physician to Queen Anne, who left £40,000 to found a library when he died in 1714.

Let's begin at St Mary the Virgin, because this is where the university first held its meetings and ceremonies in the thirteenth century. The café occupies the space where the Convocation House stood, built in 1320 where the governing body continued to meet until 1534 when they moved to the Divinity School. The fine Perpendicular Gothic interior of the church is where Archbishop Thomas Cranmer was tried before being burned at the stake in Broad Street, and where John Henry Newman, when vicar, preached and held Oxford spellbound by his words.

On the west side of Radcliffe Square stands Brasenose College, named after the 'brazen nose' door knocker which used to hang on the main gate, and which is now displayed in the dining hall. In medieval times you could claim sanctuary by grasping the knocker and holding on! On the north side of the square is part of the ancient Bodleian Library, known as the Old Schools Quadrangle, built in the seventeenth century as the home of the various schools of the university, the names painted in Latin above the doors.

Inside the Bodleian Library is the wonderful Duke Humphrey's Library, first opened in 1488 and restored by Thomas Bodley in 1602.

Opposite Brasenose College is the impressive gateway to the north quadrangle of All Souls College, home to Oxford's largest wine cellar.

Finally, right in the middle of Radcliffe Square is the Radcliffe Camera, designed by James Gibbs from an idea by Nicholas Hawksmoor and completed in 1749. It was included as a reading room as part of the Bodleian Library in 1860. There is a statue of Radcliffe by Rysbrack in a niche above the entrance.

While you are in the area, don't miss a visit to the fifteenth century Divinity School with its beautiful vaulted ceiling, the eighteenth-century Clarendon Building, original home of the Oxford University Press, and the seventeenth-century Sheldonian Theatre, designed by Christopher Wren and home to the university's degree ceremonies and a year-round programme of concerts.

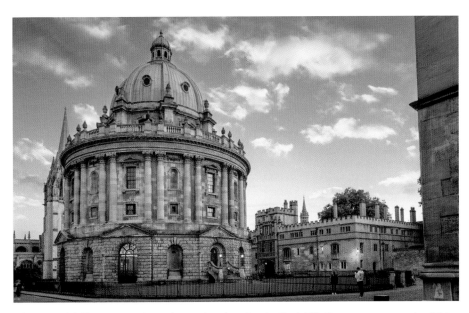

Above: Radcliffe Square in the early evening showing the Radcliffe Camera, 1737–49, by Gibbs, and Brasenose College, founded by William Smith, Bishop of Lincoln, in 1509. (Stuart Vallis)

Below: An aerial view of the area around Radcliffe Square, showing the Church of St Mary the Virgin, All Souls' College, the Bodleian Library and Brasenose College, with the Radcliffe Camera in the centre. (Robert Lind)

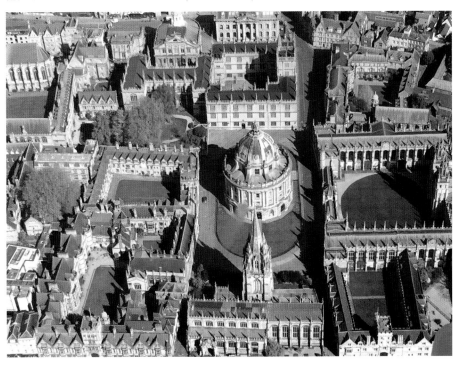

32. The University and Pitt Rivers Museum

Opposite Keble College on Parks Road is another extraordinary piece of Victorian Gothic architecture inserted into Oxford's medieval splendour, the University Museum. The building was erected between 1855 and 1860, designed by Benjamin Woodward, and Thomas Deane, but it breathes the influence of John Ruskin and his belief in the nobility of manual labour and hand craftsmanship. It was built using the structural techniques of the railway age with stone columns, iron girders, and a glass roof. Much of the stonework was fashioned by Irish labourers, especially the O'Shea brothers, who created wonderful freehand carvings of monkeys, cats, fruits and vegetables, but were accused by the university authorities of defacing the building with unauthorised work. According to Sir Henry Acland, who initiated the idea for the museum, they retaliated by carving parrots and owls as caricatures of members of Convocation who had dared to criticise their work.

The building consists of a large court 120 square feet in size with a glass roof, surrounded by open arcades and galleries.

The most spectacular exhibits are the dinosaurs, especially the giant lizard, 50 feet long and 16 feet high, and the dodo. There are displays on the themes of evolution,

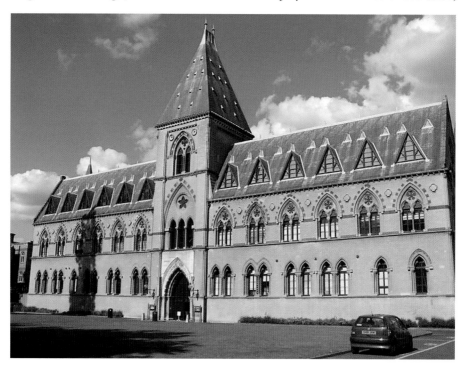

The University Museum on Parks Road, 1855–60, by Benjamin Woodward. (Stuart Vallis)

primates, the history of life, vertebrates, invertebrates, and rocks and minerals. There are a number of stuffed animals, and some splendid dinosaur footprints set in the front lawn of the museum. To the right of the building is the original Chemistry Laboratory, its design based on the Abbot's Kitchen at Glastonbury, and opened in 1860.

At the rear of the University Museum, and only accessible by walking through the main building, is the Pitt Rivers Museum, an extraordinary anthropological collection that is unique in the country. General Augustus Henry Lane Fox Pitt Rivers (1827–1900) was an officer in the British Army who served in the Crimean War. He was an ethnologist and archaeologist who travelled widely, collecting examples of the evolution of native customs and crafts. His interest began with the evolution of the rifle, and then extended to other weapons and tools, and he began collecting human artefacts from all over the world amongst a variety of races and tribes.

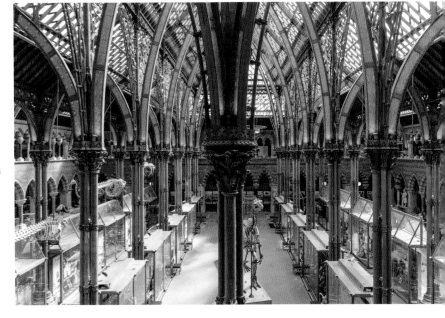

Interior of the University Museum, with iron columns supporting a glass ceiling, extravagant wrought-iron decoration and elaborate stone carving on the piers.

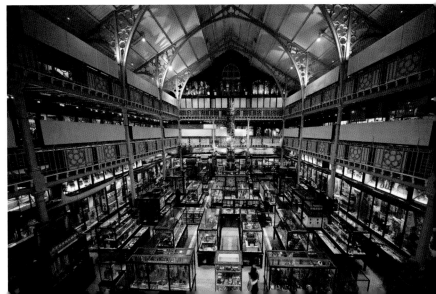

The interior of the Pitt Rivers Museum, 1885–86, housing a vast and diverse collection of ethnographic artefacts from all over the world.

33. Worcester College Gardens

One of the remoter colleges, Worcester lies at the end of Beaumont Street, standing in 26 acres of grounds, with an eighteenth-century atmosphere exemplified by the central gate and quadrangle, all bearing the stamp of the architect Nicholas Hawksmoor.

Although refounded in the early eighteenth century, the college's origins go back to the thirteenth-century Gloucester College, founded by Benedictine monks in 1283. After the Dissolution of the Monasteries it became an academic hall attached to St John's College before being refounded by the Worcestershire baronet Sir Thomas Cooke in 1714. The hall and chapel were designed by James Wyatt in the 1770s, and the chapel was redecorated between 1864 and 1866 by the exuberant High Victorian architect William Burges, who covered the walls with frescoes and filled the windows with exotic stained glass. One side of Pump Quad is filled with a row of delightful fifteenth-century cottages which were once part of Gloucester College. At the far end is an archway and a tunnel leading to the celebrated gardens, and referred to in Lewis Carroll's *Alice's Adventures in Wonderland* as 'not much larger than a rathole' leading 'to the loveliest garden you ever saw'.

Worcester College Gardens, with the eighteenth-century buildings in the background.

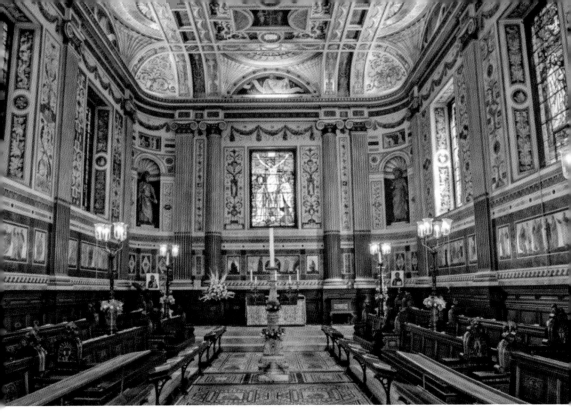

Interior of Worcester College Chapel, completed in 1791, but redecorated by William Burges in 1864, with decoration and stalls by Burges and stained glass by Henry Holiday.

Although founded late, the college was fortunate to be sited on the edge of the city, where plentiful land was available. This allowed the college to retain extensive gardens, landscaped in the Picturesque style with magnificent trees and shrubs as well as a lake. Extensive work was carried out in the early nineteenth century after the completion of the Oxford Canal, which forms the western boundary of the college grounds. The gardens have won numerous awards, and are managed by a team of eight gardeners. Occasionally roe deer are seen in the grounds, and there is a great variety of birdlife on the lake, including swans and their cygnets, goosander and cormorants, kingfishers and heron.

South Oxfordshire

34. Bix Bottom

Bix is a small settlement on a ridge of the Chilterns around 2.5 miles north of Henley-on-Thames. The name 'Bix' means a hedge, and 'Bottom' comes from the Old English for a broad valley floor.

Bix Brand's original church, St James', dating from Norman times, was abandoned in 1875 and is now an overgrown ruin. A new church was built in the centre of the village in 1874, and contains the 700-year-old font and two panels of sixteenth-century glass.

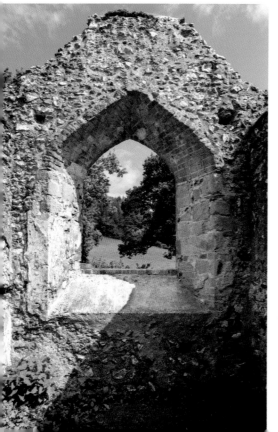

The old church of St James, Bix Bottom, abandoned in 1875 and now overgrown. (Stuart Vallis)

In the deep hollow of Bix Bottom, north of the village, is the Warburg Nature Reserve. This Site of Special Scientific Interest, consisting of chalk grassland and ancient woodland, was established in 1965. It contains over 2,000 species of plants, birds, mammals and fungi, and is managed by the Berks, Bucks and Oxon Wildlife Trust (BBOWT). It is the richest BBOWT site for orchids, and forty kinds of butterfly have been seen here. In spring there are wonderful carpets of bluebells and wood anemones, in summer wild marjoram and thyme, and in the autumn Chiltern gentians and over 900 species of fungi. If you arrive early enough in May and June you can hear the dawn chorus echoing around the valley bottom.

Bix Bottom Nature Reserve. (Stuart Vallis)

35. Clifton Hampden

Round Clifton Hampden, itself a wonderfully pretty village, old-fashioned, peaceful, and dainty with flowers, the river scenery is rich and beautiful. If you stay the night on land at Clifton, you cannot do better than put up at the 'Barley Mow'.

So wrote the famous author Jerome K. Jerome in 1889 in his book *Three Men in a Boat*. And today Clifton Hampden looks just as pretty, although rather busier, with the church beautifully sited on a low cliff above the river, and timbered and thatched cottages surrounded by the elms and willows that border the Thames.

The river here is crossed by a good brick bridge of seven arches designed by the Victorian architect Sir George Gilbert Scott. The story goes that Scott was dining at Clifton Hampden with Lord Aldenham, a rich banker's son, who had had the church restored in memory of his father. Lord Aldenham happened to mention that his servants, who lived in Long Wittenham, were always missing the ferry, which had been the only means of crossing the river since the fourteenth century. Scott thereupon designed a bridge on his shirt cuff and told Lord Aldenham that the local clay was suitable for making bricks. John Casey, the last ferryman, built the bridge himself with bricks baked on Clifton Heath, and became the first toll keeper. And

The bridge at Clifton Hampden, rebuilt by George Gilbert Scott in brick with seven arches in 1864. (Stuart Vallis)

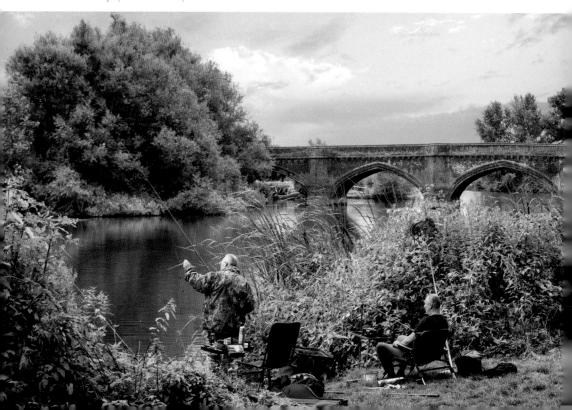

St Michael and All Angels Church, Clifton Hampden, restored by George Gilbert Scott in 1844 and 1866. It stands perched on a cliff overlooking the River Thames. (Stuart Vallis)

so the bridge was built that still carries traffic across the Thames today. Scott had already, in 1844, rebuilt the parish church of St Michael and All Angels. Henry Gibbs (1819–1907), the first Lord Aldenham, had been determined to restore and beautify the church, and together with Scott they employed skilful craftsmen to build the church, and to carve and fill the windows with stained glass by Thomas Willement, and Clayton and Bell. The chancel became a 'founder's chapel' in memory of George Gibbs, with his tomb on the north side under a richly crocketed canopy, a mosaic of the Last Supper by C. Buckeridge, and an elaborate brass screen with a gilded figure of St Michael and Angels by J. F. Redfern. The whole ensemble standing on its rock above the river is a good example of the kind of restoration that the nineteenth century religious revival inspired.

36. Didcot Railway Centre

Didcot is an important junction on the Great Western Railway, where a branch goes off to Oxford and the Midlands. The GWR reached Didcot in 1839 and the station opened in 1844, causing the town to expand. Didcot became a maintenance and stabling depot because of its strategic position midway between London and Bristol, and in 1932 a four-road engine shed was built, with a coaling stage, turntable and offices. When steam traction was replaced by diesel the shed was closed in 1965, and was offered to the Great Western Society (GWS) who took it over in 1967 and leased the site from British Rail.

Over the years the GWS have developed the site, retaining many original features. It is a working steam locomotive and railway museum, with a short stretch of line that offers rides to visitors. From Didcot Parkway station you enter the site at the southern end where the coaling depot is. This is the only surviving example of a type of building that was commonplace at railway depots. Wagons loaded with coal were propelled up the steep incline, and the coal was transferred into tubs which tip up to deposit the coal in the locomotive on the line below. You then come to the engine shed, the repair shed, and the locomotive works, built in 1988. Nearby is the signalling centre, where you can learn how the movement of trains was controlled in the last century, contrasting with the signalling system of Brunel's day when lineside constables controlled trains using a system of flags. Beyond this is the turntable, originally installed at Southampton Docks. There are sheds with locomotives of every kind, old signal boxes, coaling points, old tin-plate advertisements, and three short lengths of track: the Branchline starts at a typical Great Western Railway Halt, and runs to a platform named Burlescome Station, and the Broad Gauge shed; the Broad Gauge Line starts from the trans-shipment shed and runs back down the Branchline; and the Mainline starts from the Main Line Platform and runs along the eastern edge of the site to a newly built platform, Oxford Road Station.

Steam trains operate on at least two of the demonstration lines, and there are special steam days all through the summer months.

Above: Shunting Engine 604 Phantom at Didcot Railway Centre. (Stuart Vallis)

Below: Great Western Tank Engine 1340, *Trojan*, preparing to depart from Burlescombe Station, Didcot Railway Centre. (Stuart Vallis)

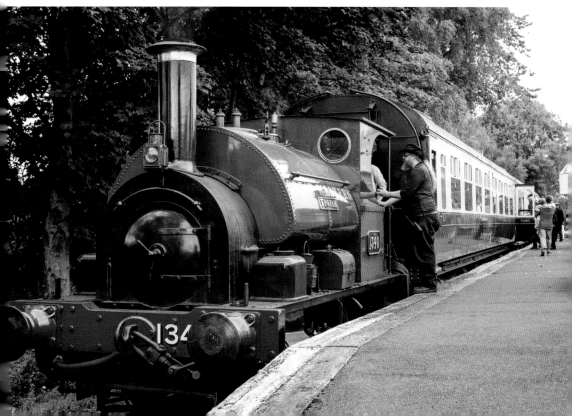

Passengers are warned not to cross the lines as the signal lets the train leave the station across the points. Didcot Railway Centre. (Stuart Vallis)

37. Dorchester

This historic village which sits at the confluence of the rivers Thame and Thames, 9 miles south of Oxford, is one of the oldest 'cities' in England. Traditionally, the River Thames downstream of the village is called 'The Thames', while upstream it is called 'The Isis'.

After the Roman period Dorchester became an important place, the seat of a bishopric and centre of the See of Wessex from AD 634 to 707, when the See was transferred to Winchester. An abbey was founded here in 1140, but it was dissolved by King Henry VIII in 1536, and was bought for £140 by Richard Beauforest, a relative of another Richard Beauforest who had been Abbot of the monastery just before the Reformation. He is commemorated by a splendid brass set in the chancel floor, showing him in abbot's robes with a fur hood, and a crosier under his right arm. The second Richard Beauforest then presented the church to the parish.

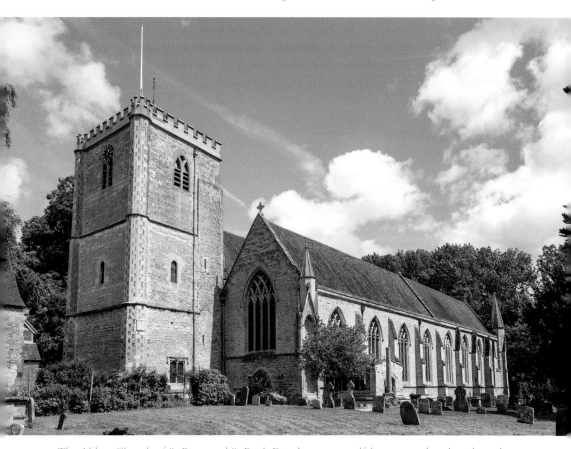

The Abbey Church of St Peter and St Paul, Dorchester, a twelfth-century church, enlarged in the thirteenth and fourteenth centuries, with a seventeenth-century tower. (Stuart Vallis)

The church as we see it today looks strangely one-sided, but with a glorious fourteenth-century choir, fine windows, especially the north window with a Tree of Jesse showing Christ's ancestors, the Wise Men bringing gifts, King David playing his harp, and the Madonna and Child; and a lively carving of a 'green man' over a doorway in the south-east corner. There are many fragments of medieval stained glass, a fine twelfth-century lead font, one of only thirty left in Britain, the reconstructed shrine of St Birinus, and a beautiful thirteenth-century effigy of a knight in armour vigorously drawing his sword.

The Sanctuary, with its three traceried windows, is the heart and glory of the Abbey. Built in around AD 1340, it contains some of the best fourteenth-century glass in Oxfordshire. The antiquary Anthony Wood visited in 1657 and recorded that the chancel walls were painted 'very gloriously' with beasts including a 'lyon, a griffin and a leopard'. The Jesse Window of around 1340, on the north side of the Sanctuary, is particularly fine, and the whole decorative programme of the Sanctuary was designed to illustrate the drama of Redemption from the Old to the New Testament, culminating in the life of Christ as shown in the great East Window.

If you have time there is a very pleasant walk to Little Wittenham on the other bank of the Thames, from where you can climb Wittenham Clumps, a pair of wooded chalk hills with fine panoramic views over the Berkshire and Oxfordshire countryside.

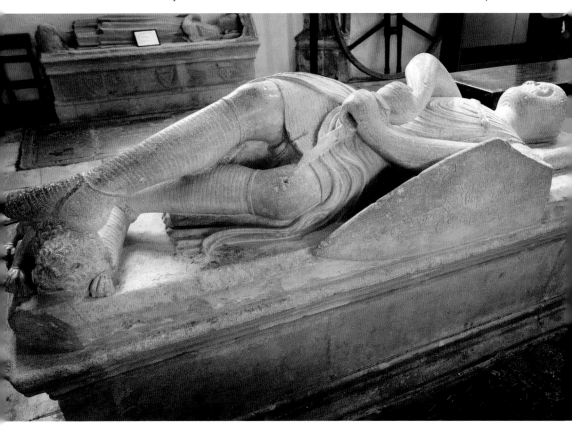

The Effigy of a Knight, *c.* 1280, showing him cross-legged and vigorously drawing his sword. Dorchester Abbey. (Stuart Vallis)

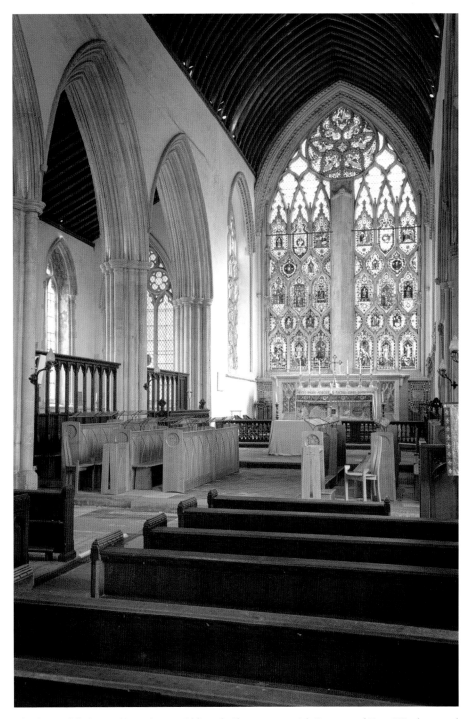

The beautiful choir of Dorchester Abbey, built *c.* 1340, with Decorated East Window, and Jesse Window to the north. (Stuart Vallis)

38. Ewelme

The brook, called Lawelme in the Domesday Book, gave its name to this picturesque settlement in the Chiltern Hills. In the Early Middle Ages the lord of the manor founded a church here, but it wasn't until the fourteenth and fifteenth centuries that Ewelme reached the peak of its fortunes, when the manor was held by the Burghersh, Chaucer and de la Pole families.

In particular, Alice Chaucer (1404–75), heiress to the manor and successively Countess of Salisbury and Duchess of Suffolk, made Ewelme her favourite residence, and spent lavishly to beautify and improve the church, and the attached complex of almshouses, school and hospital which had been founded in 1436 by William de la Pole, Duke of Suffolk. The foundation provides for a master of the almshouse and master of the school, and thirteen almsmen. As the church guidebook says:

> All three elements still function today, offering in the twenty-first century settings for worship, and community events, sheltered housing and primary education. God's House at Ewelme is at once a display of wealth, power and political connections, an outstanding example of fifteenth century art and architecture, and a living scheme of pious and practical religious belief, applied from cradle to grave and beyond.

The Church of St Mary, Ewelme, with the almshouses, and school below. (Stuart Vallis)

The church we see is largely the result of re-buildings by the Chaucers and the de la Poles between 1420 and 1470, and is built of flint and stone. At the end of the south aisle is the chapel of St John the Baptist, its walls and roof covered with the letters IHS. There is a pavement of ancient tiles, and fragments of fifteenth-century glass. This is the chapel to which the Master and thirteen almsmen would come every day to pray for the souls of the Chaucer and de la Pole families.

On the north side are the splendid tombs of Thomas and Maud Chaucer (d. 1434 and 1436), with their figures in brass on the top, and that of their daughter Alice, Duchess of Suffolk (d. 1475), the foundress, wearing the Order of the Garter on her left arm. The tomb is decorated with twenty-four enamelled shields recording the family's alliances, with the alabaster effigy of Alice above, and her emaciated cadaver below, combining earthly splendour with a reminder of human mortality.

From the West Door a flight of steps leads down to the hospital or almshouse, built of brick, and forming a cloister around a picturesque quadrangle. The school buildings are also of brick with Perpendicular windows.

In the churchyard is the gravestone of Jerome K. Jerome, author of *Three Men in a Boat*, whose house, Troy, was nearby.

King James I in 1617 annexed the Mastership of the Almshouses to the Regius Professorship of Medicine at Oxford, an arrangement which continues to the present day.

The magnificent tomb of Alice, Duchess of Suffolk, the granddaughter of the poet Geoffrey Chaucer. She died in 1475 and is commemorated by this alabaster effigy with weepers holding heraldic shields. (Stuart Vallis)

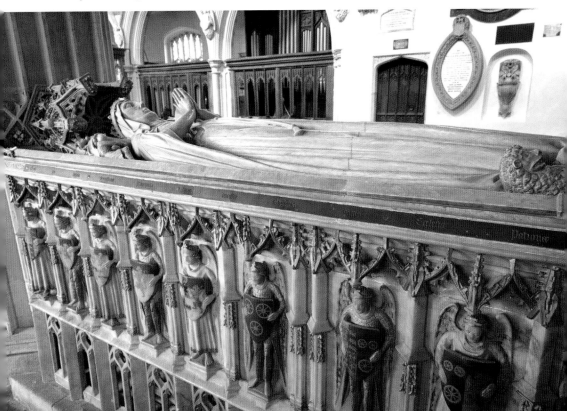

The courtyard of the almshouses at Ewelme founded in 1437 by the Earl and Countess of Suffolk to house thirteen poor men and two chaplains. The structure is of half timber and brick, one of the earliest examples of the use of brick in Oxfordshire. (Stuart Vallis)

39. Goring and Streatley

The two ancient riverside villages of Goring and Streatley, one in Oxfordshire and the other in Berkshire, are situated on either side of the River Thames at a particularly spectacular point, as the river flows through the Goring Gap, with the Berkshire Downs on one side and the Chiltern Hills on the other. As the *Murray's Little Guide to Oxfordshire* explains, the crossing from Goring to Streatley 'marks the spot where the Thames exchanges the broad plain of its upper course for the chalk gorge, which it traverses until it finally escapes at Maidenhead'. The two villages operate as one interdependent community, with the railway station on the Great Western line named 'Goring and Streatley'.

Streatley Mill, the lock and the weir make a delightful picture, with the Swan Inn on the Streatley bank, and the tower of Goring Church visible over the trees. In around AD 1150 a nunnery was founded here, and the nuns built onto the east end of the church, erecting a screen between the two. The original priory must have been an extensive complex of buildings, including a cloister, infirmary, a dormitory, refectory, and guest house. The nunnery was destroyed at the time of the Dissolution of the Monasteries.

The fine Norman tower contains one of the oldest bells in England, made around AD 1290, and there is an attractive memorial brass on the north wall to Elizabeth

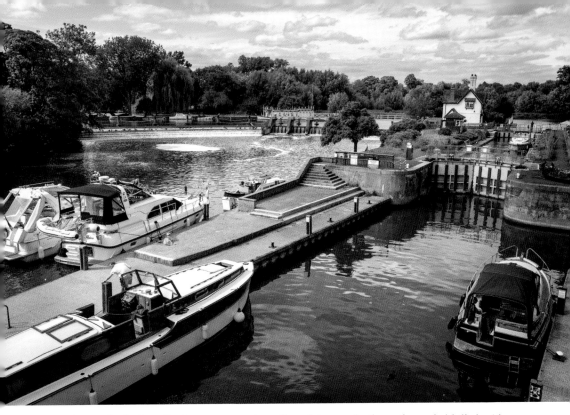

Above: The lock at Goring, an attractive village lying at the foot of wooded hills beside the Thames, and always a hive of activity during the summer months. (Stuart Vallis)

Below: One of the old Oxford College barges moored by the Swan Hotel at Streatley, with paddleboarders in the background. (Stuart Vallis)

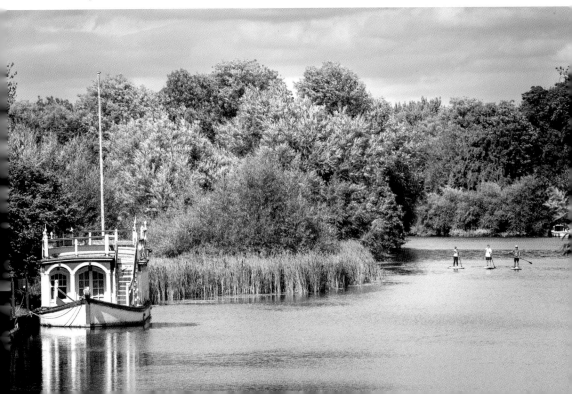

Loveday (1401), showing her beneath a canopy in gown and mantle, with a little dog at her feet.

There is an attractive collection of shops in Goring High Street, and the Swan Inn on the Streatley bank, now a smart luxury hotel, offers excellent accommodation and food, and stunning riverside views. It has had a colourful history, having once been owned by cabaret star Danny La Rue.

On a fine summer's day the area around Goring and Streatley is a great spot to visit, bustling with activity on the river, and if you follow a track beyond Goring and Streatley Station you will discover Hartslock Nature Reserve, (BBONT).

40. Henley-on-Thames

Henley is a charming and busy town set in a beautiful position on the banks of the Thames. It is best approached from Remenham Hill, from where you see the attractive ensemble of the bridge, the river, the church tower and the Angel Inn which dates from 1728. The handsome bridge was erected in 1786, and the heads on the keystones of the central arch represent the Thames and the Isis, the former a river god with a flowing beard, the latter a youthful maiden. They were carved by the sculptor Anne Damer, a cousin of Horace Walpole.

A thriving town with a market was recorded here from the thirteenth century. It had grown considerably by the sixteenth century, and enjoyed its greatest prosperity in the seventeenth and eighteenth centuries because of the manufacture of glass and malt. There are many fine buildings in the town, including the Red Lion Hotel by the bridge, the Town Hall at the upper end of the main street, the almshouses and the Chantry House, a half-timbered building which was formerly a fourteenth-century grammar school, and the parish church of St Mary the Virgin, with its fine sixteenth-century flint and stone tower.

Just outside the town centre, on Mill Meadows, is the River and Rowing Museum, opened in 1998, with exhibitions about the Thames, the story of rowing, the story of the town of Henley itself, and of Kenneth Grahame's delightful children's novel *The Wind in the Willows*, published in 1908. Grahame had been Secretary of the Bank of England, but in 1908 he retired and moved back to Berkshire, his childhood home, to spend his time by the River Thames, 'simply messing about in boats'. The resulting bedtime stories, which he had earlier told to his son Alastair, became the basis for his charming book, which concerns the activities of Mole, Rat, Toad and Badger.

Henley, of course, is well known for the famous rowing regatta in June, which was first held in 1839 and has been held annually ever since. It was originally staged by the town mayor as a public entertainment with a funfair, but rapidly changed into the international competitive amateur competition which draws crews from all over the world.

The traditional length of the course is 1 mile 550 yards, or 2,112 metres, which was the longest distance of open water available in 1839. The area of water meadow on the Buckinghamshire bank has been designated a Site of Special Scientific Interest, a sanctuary for flora and fauna, and all the tents, marquees and other regatta

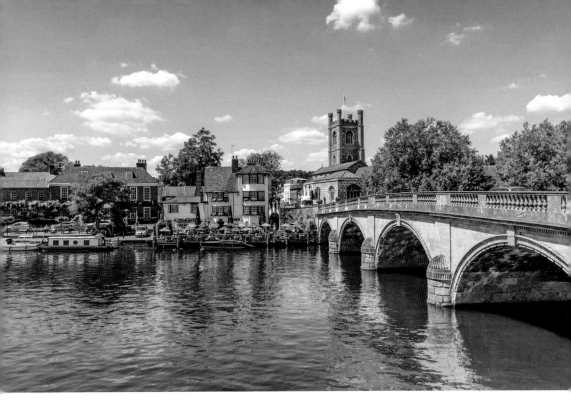

Above: The elegant eighteenth-century bridge over the Thames at Henley, with the tower of St Mary's Church beyond, built by John Longland, Bishop of Lincoln between 1521 and 1547. A delightful and bustling town with a Georgian feel, on the banks of the River Thames. (Stuart Vallis)

Below: The internationally famous Henley Rowing Regatta in full swing on a glorious June day.

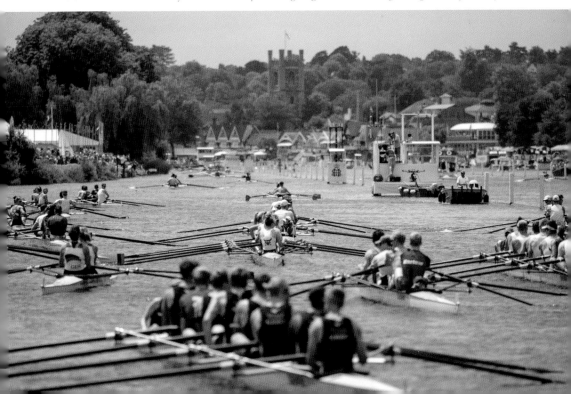

installations are removed every year to preserve the beauty and tranquillity of this lovely stretch of the River Thames.

41. Iffley

This lovely village by the Thames is now somewhat swamped by the growth of the City of Oxford, but manages to retain its character. It is best seen from the river 'when the church appears at the end of a beautiful reach, above the willows which fringe the river banks' (*Murray's Guide*).

The glory of the village is the church of St Mary, built around AD 1170 by the powerful St Remy family, and one of the finest examples of Norman architecture in England. The West Front of the building is a marvel of Norman Romanesque design with its beakhead carvings of animal figures, signs of the zodiac and emblems of the Evangelists, and above a splendid circular window.

The North and South Doors are also very fine with more fantastic animals, serpents, and a Green Man. There is a medley of flowers and mythical beasts, including centaurs fighting knights on horseback on the capitals of the pillars on either side of the South Door. The South Door is unfinished, reputedly because the masons were called away to work on St Frideswide's Priory in Oxford.

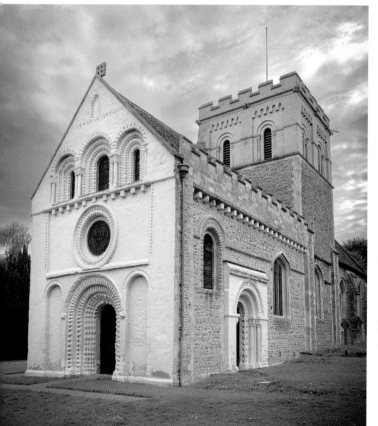

The magnificent Norman Church of St Mary at Iffley, built *c.* 1170–80 by the St Remy family, with much zigzag and beakhead carving. (Stuart Vallis)

Inside there is a massive Norman font, made from Tournai marble, more Norman carved arches, and a beautiful thirteenth-century chancel with contemporary vaulting, piscina and sedilia.

Next to the church is the former Rectory, dating from the twelfth century. Church Way is winding and picturesque with the thatched school of 1838, a house with the inscription 'Mrs Sarah Newell's School 1822', and the Tree Hotel, an eighteenth-century inn, with nearby the great elm tree that was already 100 years old in 1714.

42. Kelmscott

This remote village in the south of the county, where the River Thames winds through flat lush meadows, is where the nineteenth-century writer and artist William Morris made his home at Kelmscott Manor, an Elizabethan house with gables and mullioned windows which he described as 'Heaven on Earth'. It became the inspirational retreat for Morris, the Victorian textile designer, poet, novelist and father of the Arts and Crafts movement.

William Morris formed a brotherhood with Edward Burne-Jones and Dante Gabriel Rossetti which promoted handmade work produced by craftspeople. Morris's passion for conservation led him to found the Society for the Protection

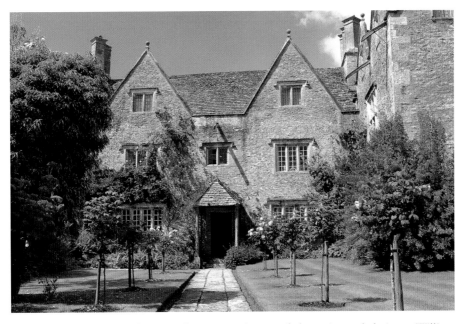

The manor house at Kelmscott, the country house of the artist and designer William Morris from 1871 to 1896. The house dates from the sixteenth century with later additions.

William Morris' bed, made from Elizabethan and Jacobean woodwork, with elaborate tapestry hangings made by his daughter May in 1891–93.

of Ancient Buildings, and his last venture was the Kelmscott Press, for which he designed types, ornamental letters and borders.

Morris loved Kelmscott Manor, 'this loveliest haunt of ancient peace', and its associated farm buildings as a work of true craftsmanship, unspoilt and unaltered, and in harmony with the surrounding countryside. The stone for the windows came from local quarries, and the roof timbers were made from Kelmscott elm trees, fixed together with nails made by the village blacksmith.

Today the house is owned by the Society of Antiquaries of London, and the house and garden are usually open to the public. William Morris died at Hammersmith in London in 1896, and was buried at Kelmscott. He lies in the graveyard of the little church of St George, beside his wife, his tombstone designed by Philip Webb.

43. Newbridge: The Rose Revived

The 'new bridge' over the River Thames, which gives its name to this lovely spot, is in fact a fine fourteenth-century bridge which carries the road from Abingdon to Witney over the river. It is one of the oldest surviving bridges on the Thames, and

consists of two spans, the southern span being dry underneath except when the river floods. The bridge was built of Taynton stone by the monks of Deerhurst Priory in Gloucestershire, on the orders of King John to assist communication between the Cotswold wool producers and key wool towns.

The bridge is of similar design to that at Radcot, but longer, and with pointed niches in which pedestrians could take refuge. It was originally much longer than the surviving structure, as a seventeenth-century manuscript makes clear: 'New Bridge on Bark Shire side has 17 arches to ye main bridge … Over on the Oxford Shire side beyond ye main bridge are 28 arches…' These causeway arches were probably demolished in the nineteenth century, but even so what is left is one of the most beautiful and stylish old bridges in Britain.

At the end of the bridge on the Oxfordshire side is the Rose Revived, a delightful sixteenth-century Cotswold stone inn, now a smart gastro-pub with rooms.

Bridge and inn (and indeed the Maybush Inn on the south bank) make a charming composition, and cannot be bettered if you want a drink in an Oxfordshire inn beside the Thames. The place holds a special personal association for me, because it was here in 1940 that my parents got engaged at the most anxious period of the Second World War – a moment of peace and commitment in those dark and uncertain days.

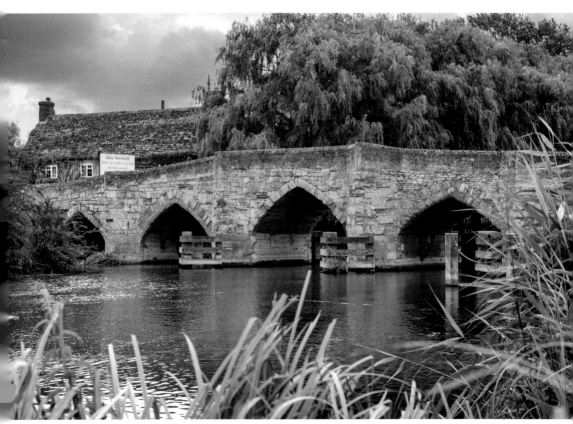

The fine medieval bridge at Newbridge, dating from the late fourteenth century, with its six pointed arches divided by triangular buttresses. (Stuart Vallis)

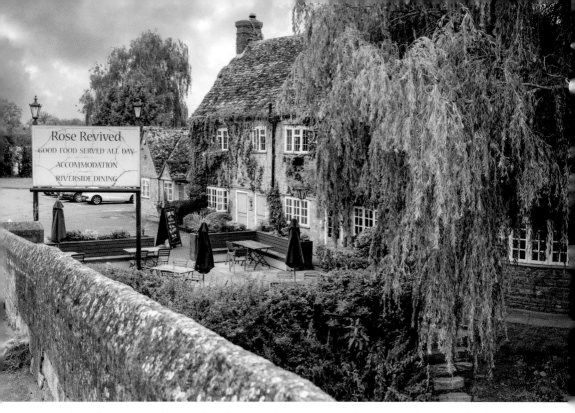

The Rose Revived Inn at Newbridge, lying at the junction of the rivers Windrush and Thames. (Stuart Vallis)

44. Nuffield Place

Situated in the Chiltern Hills at 650 feet above sea level, and affording magnificent views across the Thames to the Berkshire Downs, is Nuffield Place, the home of William Richard Morris, the car manufacturer, who became Lord Nuffield. The house was built in 1914, and was bought and enlarged by Lord Nuffield in 1933. When he died in 1963 he bequeathed the house and contents to Nuffield College, Oxford, as a museum, and they in turn presented the house to the National Trust in 2017, who now maintain it and open it to the public.

Lord Nuffield invented the Morris motor car, which made him one of the richest men in Europe at the time. Even so, he chose to live in a relatively modest but comfortable home, designed by Oswald Milne, a pupil of Edwin Lutyens. The house has been left as it was when Lord Nuffield and his wife lived there, a time warp of the pre-war period. Morris was fascinated by gadgets and clocks, and had a small workshop installed in his bedroom, a sort of concealed cupboard that opens up to reveal a wonderful array of tools, a vice, and, bizarrely, a jar containing his own preserved appendix.

There are many clocks scattered throughout the house, including four grandfather clocks in the hall, and other gadgets, including an early toaster, a Cona coffeemaker, and heated towel rails in the bathroom. Both Lord and Lady Nuffield were keen

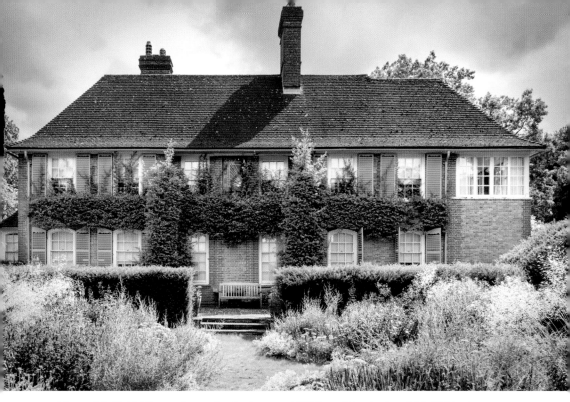

Above: Nuffield House, formerly the home of William Morris, Lord Nuffield, the car manufacturer and philanthropist. (Stuart Vallis)

Below: The Drawing Room at Nuffield House, showing the comfortable but unpretentious style in which Lord and Lady Nuffield lived. (Stuart Vallis)

cyclists, as befitted a man who was apprenticed, at the age of fifteen, to an Oxford bicycle repairer. He soon set up his own firm, diversifying first into motor bicycles and then into car manufacture.

Nuffield made millions from the motor car, but he was also a great philanthropist, giving away around £30 million over his lifetime (equivalent to around £700 million today). He died in 1963, and was buried in the churchyard of Nuffield parish church.

45. Rotherfield Greys

Deep in the Chiltern Hills, west of Henley, is the charming hamlet of Rotherfield Greys, worth visiting both for the parish church of St Nicholas and for Greys Court, the former manor house of the Grey family and now owned by the National Trust.

The village can be traced back to 1086, the name Rotherfield coming from an Old English word meaning 'cattle lands'. The centre of the parish is Greys Green with its cricket pitch, and further on the charming Maltsters Pub, and St Nicholas Church, rebuilt in 1865 but containing the Knollys Chapel, built in 1605 by William Knollys, 1st Earl of Banbury, and housing a vast alabaster monument with recumbent effigies to Sir Francis and Lady Catherine Knollys (1596) and their kneeling children – Lord William Knollys (1632) and his wife kneel above them. Catherine Knollys was the daughter of Mary Boleyn, sister of Anne, and reputedly a mistress of Henry VIII. It is an extraordinarily showy piece, with canopy, urns and cherubs.

The church also contains one of the finest brasses in the county, the armed figure of Sir Robert de Grey (1387) who lies in the chancel, a full-length figure under a canopy and with a lion at his feet.

Monumental brasses are flat plates of metal, many engraved with the images of those commemorated, but some just simple inscriptions. Around 8,000 brasses still remain in churches in the British Isles, a small proportion of those originally laid down between 1250 and 1700. Brasses were developed from incised stone slabs, and became popular because they were affordable, durable, and did not take up as much space in the church as a three-dimensional tomb. One of the oldest figure brasses is at Stoke d'Abernon in Surrey, Sir John Dabernoun, but the county of Oxfordshire has an excellent selection. There are some fine early examples in Merton and New Colleges. Other good brasses are to be found at Brightwell Baldwin, Cassington, Checkendon, Dorchester, Ewelme, Oddington, Swinbrook and Great Tew. They are a fascinating source of information for costume, armour, heraldry and ecclesiastical dress in the medieval period.

Beyond the cricket ground you come to Greys Court, a Tudor country house originally built in the 1570s, with a grass maze, walled garden, and Tudor wheelhouse.

The house 'has a cheerful face of red brick' (Pevsner), and in the grounds there are seventeenth-century stables, and a wheelhouse containing an old well, 208 feet deep, which can still be worked by a donkey walking inside a hollow perpendicular wheel 19 feet across. The house is surrounded by a magnificent park, across which you can see the church.

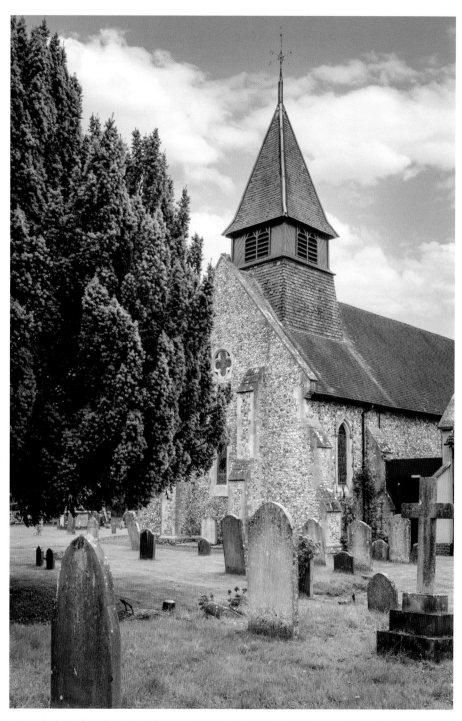

St Nicholas Church, Rotherfield Greys, rebuilt in 1865 by William Woodman. (Stuart Vallis)

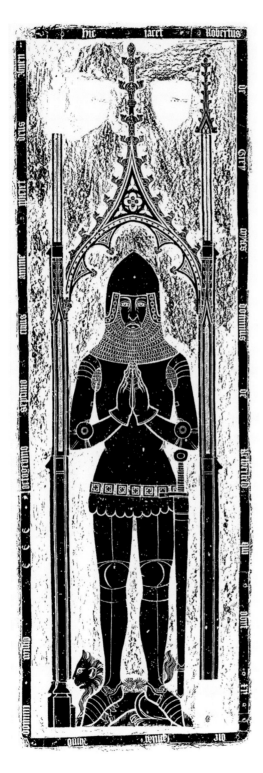

The fine memorial brass to Lord
Robert de Grey, 1387, showing
him in full armour under a canopy.
St Nicholas Church, Rotherfield
Greys. (Martin Stuchfield)

46. Rycote Chapel

In the south transept of St Mary's Church in Thame is a fine tomb-chest covered with a slab of Purbeck marble on which are the brasses of Richard and Sybil Quatremain (1465) showing him in elaborately fluted armour, with his wife wearing a mantle around her shoulders. Richard and Sybil were responsible for building Rycote Manor and the chapel beside it. This beautiful building, dedicated to Saint Michael, erected around 1449, was built by the Quatremains who paid for three priests to say Mass every day for the family. The manor house has long since disappeared, but the chapel remains, an exceptional example of a chantry chapel, retaining bench pews, early wall paintings, and a carved rood screen. The font is twelfth century, from an earlier church on the site.

The estate eventually passed to Sir John Norris, who built the extraordinary Norris Pew on the north side of the chancel in 1610, with a musicians' gallery on top. On the opposite side is the equally spectacular domed pew, reputedly built for a visit of King Charles I in 1625 when the king and his court were staying in Oxford

The glory of Rycote Chapel is its seventeenth-century fittings. This is the Norreys family pew with a musicians' gallery above.

The ornate pew in Rycote Chapel believed to have been made for the visit of King Charles I to Rycote in 1625. It has a domed canopy painted with stars on a blue background, and on the north side an arched doorway.

to seek refuge from an outbreak of plague in London. There is a Jacobean pulpit, a seventeenth-century musicians' gallery, altar rails, and many memorials.

The chapel itself, standing in the shadow of an ancient yew tree, remains just as King Charles I would have known it, still echoing to the sonorous phrases of the *Book of Common Prayer* and the *King James Bible*.

47. Shotover Hill and Boars Hill

If you want a view of the City of Oxford in all its ancient beauty and nostalgic grandeur, immortalised by the poet Matthew Arnold (1822–88) in his *Essays in Criticism*:

> Beautiful city! So venerable, so lovely,
> Whispering from her towers the last enchantments of the Middle Ages

then you will need to go up either Shotover Hill or Boars Hill. From Shotover the distant view of Oxford is best seen in the morning, and from Boars Hill it is best in the afternoon. The hills surrounding Oxford seem to be higher than they really are, and provide splendid walks along with the occasional spectacular view.

Coming over Shotover Hill travellers from London originally gained their first view of the city below when the old London Road used to pass over the top of the hill, a favourite haunt for highwaymen. The public spaces on the southwest slopes of the hill, called Shotover Country Park, are maintained as a nature reserve and managed by Oxford City Council.

To the southwest of Oxford is Boars Hill, which can be reached from the Hinksey Hill interchange of the A34. You need to climb up the road signposted Boars Hill and Wootton, turn off to the right, along Berkeley Road past Foxcombe Hall, and then take the road called The Ridgeway. On your left there is a gate and a path leading to the Wild Garden. Follow the main path to Jarn

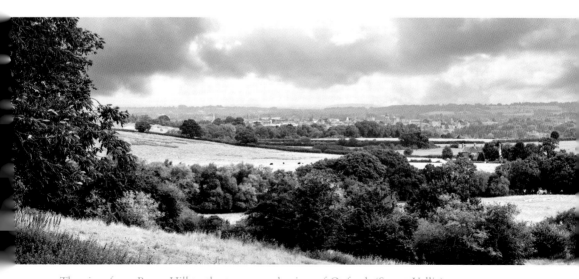

The view from Boars Hill to the towers and spires of Oxford. (Stuart Vallis)

Mound, and at the end of Jarn Way you will find Matthew Arnold's Field, where a plaque states:

> This land named Matthew Arnold's Field, being a principal foreground of the poet's vision in Thrysis and the Scholar Gypsy, was bought for the Oxford Preservation Trust through public subscription from both sides of the Atlantic.

48. Stoke Row and The Maharajah's Well

Right in the middle of this straggly village nestling in the Chiltern Hills is a most extraordinary sight – an elaborate structure which looks a bit like a bandstand, but is in fact a well with a very interesting history.

In the mid-nineteenth century the local squire at Ipsden House, Edward Anderton Reade, had worked with the Maharajah of Benares – now Varanasi – in India on an engineering project which included sinking a well. In 1857, at the beginning of the Indian Mutiny, Reade became Lieutenant-Governor of the North-Western Provinces during the Siege of Agra. The Maharajah had remained

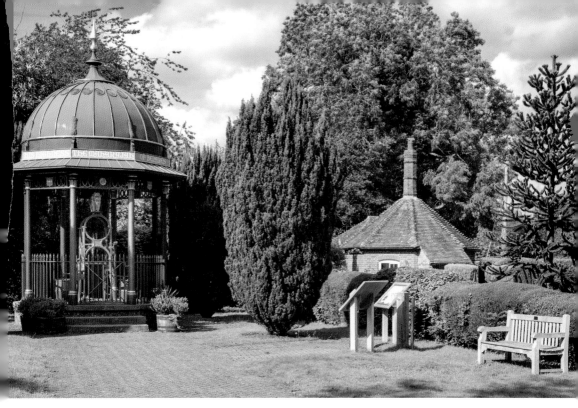

The Maharajah's Well, and Well-Keeper's Cottage, 1864, at Stoke Row, the gift of the Maharajah of Benares. (Stuart Vallis)

loyal to the British during the rebellion, and eventually this was recognised by the British government, prompting the Maharajah to his own act of generosity. After Reade's departure the Maharajah wanted to express his gratitude, having learnt from Reade about the great difficulty of obtaining water in the chalk country of the Chiltern Hills. The result was that the Maharajah commissioned a well at Stoke Row, and work began in 1863. When Reade planned the site he incorporated symbols associated with the Maharajah, such as the Trisod, the Hindu God Shiva's three-barbed dart symbol. Shrubbery in front of the warden's cottage was shaped into the Maharajah's armorial bearings, and in the cottage hung his photograph with the warden's beautifully gilded certificate of appointment.

A foundry in Wallingford made the well mechanism, and completed the Mughal pavilion with its ornamental cupola and golden elephant in 1864.

The well is 4 feet in diameter, and goes down to the height of two Nelson's columns. It took a year to complete and was opened on Queen Victoria's birthday (24 May 1864), at a cost of £400. The Maharajah also paid for a well-keeper's cottage and a small cherry orchard. Sales of the cherries provided for the upkeep of the well. The well was in use for over seventy years, and at the well's centenary in 1964 the Duke of Edinburgh visited the village, when holy water from the Ganges was brought and mixed with the well water.

The well continues to be a focal point within the village, and provides the setting for a forest school and an adventure playground. In 2014 the village gathered to celebrate its 150th anniversary.

The well mechanism of the Maharajah's Well, Stoke Row, with a golden elephant standing under the ornamental cupola. (Stuart Vallis)

49. Stonor Park

Tucked away in a lush valley in the Chiltern Hills is Stonor Park, a mansion set in magnificent, rolling parkland. There has been a house here since medieval times, which has been enlarged and restored many times over subsequent centuries. The estate is the ancestral home of the Stonor family, the seat of Lord Camoys, whose distant ancestor led the English left wing at the Battle of Agincourt in 1415.

The house has a private chapel which dates from the twelfth century and has remained in Catholic hands continuously since then. There are only two other chapels in England which have always been Catholic, so this is a special place, a centre of Recusancy during the penal times after the Reformation, and the house contains hiding places where Catholic priests were hidden from government agents.

The core of the house is medieval, with an eighteenth-century façade of red brick over an E-shaped Elizabethan house. Inside there is a maze of small rooms and staircases, the seventeenth-century library has a celebrated collection of Catholic books and documents, and there is a grand Gothic Revival Hall. The house retains an intimate family feel, and has remained remarkably unaltered because of the relative impoverishment of the Stonor family during the years of persecution and marginalisation.

There is a delightful Italianate walled garden, and beyond it a park with a herd of fallow deer. Surrounding the park are Almshill, Balham's and Kildridge woods. There is an ambitious programme of events at Stonor, including food festivals, antique fairs, outdoor concerts, and fitness workouts, all advertised on the official Stonor Park website.

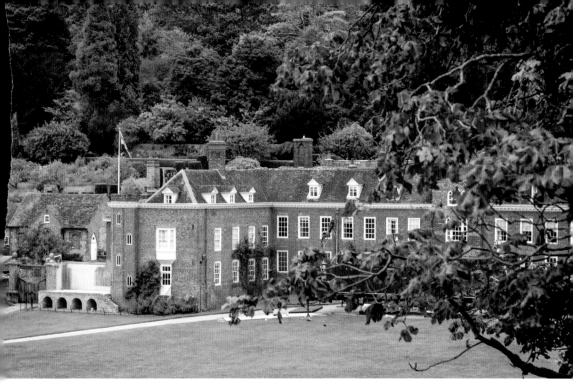

Above: Stonor House nestling in its remote valley in the Chiltern Hills, showing the remodelled façade by Sir Francis Stonor completed around 1600. (Stuart Vallis)

Below: The Chapel of the Holy Trinity, Stonor Park, a fourteenth-century church with the interior remodelled in the Gothic style in the late eighteenth century. (Stuart Vallis)

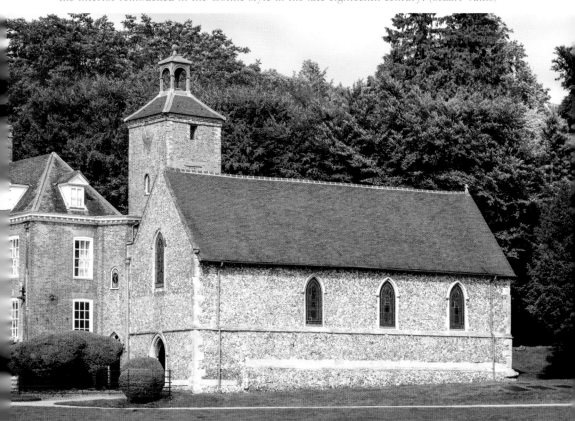

50. Wytham Woods

You reach the village of Wytham by driving through Wolvercote. There is a small cluster of cottages, the comfortable eighteenth-century White Hart Inn, a village shop, and All Saints Church, which was rebuilt in the early nineteenth century by the 5th Earl of Abingdon using material from Cumnor Place and Godstow Nunnery.

The Wytham Estate passed through many hands over the centuries, including Sir Richard Harcourt, Lord Williams of Thame, the Earls of Abingdon, and was then sold to Raymond Ffennell in 1920. He had made his fortune in gold mining, and used it to save Wytham from development. On his death he gave Wytham Woods to the University of Oxford, with the request that the beauty of the woods, farmland and village should be preserved. The university subsequently bought the remainder of the estate, and its beauty and tranquillity have been carefully maintained.

Wytham Woods is an ancient semi-natural woodland and a Site of Special Scientific Interest, rich in flora and fauna, with over 500 species of plants and 800 species of butterflies and moths. According to the website the woods can be divided into four main habitats: ancient woodland, secondary woodland, modern plantations, and the limestone grassland at the top of the hill. There are many good walks. In order to access the woods you must apply for a permit. You can find an application form on the Wytham Woods website.

An enticing path through Wytham Woods. (Stuart Vallis)

An ancient tree in Wytham Woods. (Stuart Vallis)

It is not so much for its beauty that the forest makes a claim upon our hearts, as for that subtle something, that quality of air, that emanation from old trees, that so wonderfully changes and renews a weary spirit.

Robert Louis Stevenson

Acknowledgements

The writing of this book has been a real pleasure as it has enabled me to revisit many places in Oxford and Oxfordshire which I have known over my lifetime and which hold fond memories. I owe a particular debt of gratitude to Stuart Vallis, who has travelled around the county and taken most of the splendid photographs that adorn the text. I would like to express my gratitude for the two aerial photographs to Robert Lind, and the pilot of the helicopter from which they were taken, Captain Barry Flower. I would also like to express my thanks to the incumbents of the churches chosen for inclusion, to the Lord Saye & Sele at Broughton Castle, His Grace the Duke of Marlborough at Blenheim Palace, the National Trust at Chastleton House and Nuffield Place, and to Hook Norton Brewery and Didcot Railway Centre. Once again I am very grateful to Tracey Salt for typing and retyping my manuscript with great accuracy and patience. I would like to thank Connor Stait and all at Amberley Publishing for their help and support, and above all my wife Rosemary for her support and encouragement as I wrote the book and travelled around the glorious county of Oxfordshire. To her I dedicate this book with my love and gratitude.

An aerial image of Oxford.

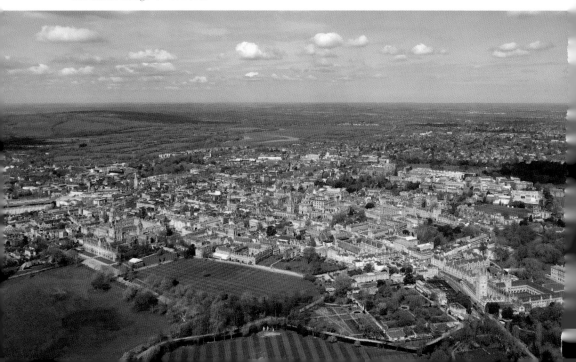